LONG ISLAND

ITALIAN AMERICANS

LONG ISLAND
ITALIAN AMERICANS

HISTORY, HERITAGE & TRADITION

SALVATORE J. LAGUMINA

THE
History
PRESS

Published by The History Press
Charleston, SC 29403
www.historypress.net

Copyright © 2013 by Salvatore J. LaGumina
All rights reserved

First published 2013; Second printing 2014

ISBN 978.1.5402.0782.1

Library of Congress Cataloging-in-Publication Data

LaGumina, Salvatore John, 1928-
Long Island Italian Americans : history, heritage and tradition / Salvatore J. LaGumina.
pages cm. -- (American heritage)
ISBN 978-1-60949-870-2 (pbk.)
1. Italian Americans--New York (State)--Long Island--History. 2. Long Island (N.Y.)--
History. I. Title.
F127.L8L343 2013
305.85'1073074721--dc23
2013027701

CONTENTS

INTRODUCTION

This is a study of American history, but more precisely, it is a study of an aspect of American history—the ethnic dimension as it figured in the development of Long Island, New York history. It is concerned with the factors and forces that were operative over the past century and a quarter as Italian immigrants and their issue moved into an area of New York that is home to millions of people and is one of the most prosperous and vibrant areas of the country. The migration of Italian Americans into the longest island on the eastern seaboard of the United States began during a time when Long Island—Nassau and Suffolk Counties—was rural, bucolic and sparsely populated and reached its height in the post–World War II era that witnessed massive movement from the city to the suburbs. The Long Island explosion in housing, population, industry, construction, education and a variety of social, cultural, religious and political initiatives became a prototype for a nation on the move. This volume focuses on Italian Americans who formed the largest cohort of this important development. To learn their history is to learn much about recent American history.

Chapter 1
STIRRINGS

For over a generation, Italian Americans—a term that encompasses those whose ancestry includes at least one parent or ancestor of Italian descent as well as those who identify themselves as Italian American in the United States census—have been the largest single ethnic/nationality group on Long Island. Into the second decade of the twenty-first century, they represent about one of every four residents of Nassau and Suffolk—the two counties commonly referred to as Long Island in contradistinction to the inclusion of Queens and Brooklyn, which are physically part of the island landmass. As such, their numbers in the two counties constitute the largest concentration of people of Italian descent in two contiguous counties outside Italy.

The history of Italian immigration to Long Island, while unique in many respects, largely mirrors the saga of mass immigration that embraced the years from the late 1880s to World War I. Known as the era of "New Immigration," that period found millions of newcomers from eastern, central and southern Europe entering the nation's expanding cities especially on the East Coast. Among the causes of immigration, in general, were religious and political persecution, as in the case of Russian Jews, and restricted educational prospects that offered little hope to aspire beyond their conventional station in life for Europeans as a whole.

A combination of push-pull factors was at work on Italian American immigrants in the decision to withdraw from the land of their birth and ancestors and from a society that reflected everything they held dear to a new

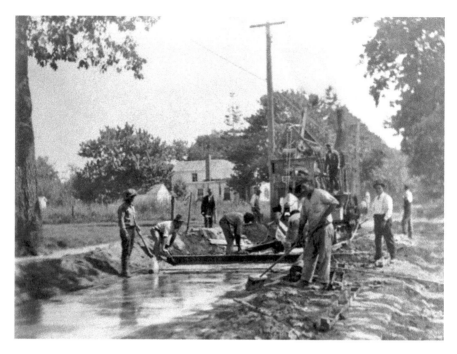

Italian American workers of Romeo Construction Company building Route 112 in Suffolk County.

country about which they knew little and where they would be distinctive minorities. Among the push factors were a desire to escape mandatory military service, the denial of opportunities to engage in meaningful political enterprises that governed their lives and conditions that precluded genuine opportunities to earn a livelihood for themselves and their families. Conversely, the pull factors, those that served as a distant magnet that enticed them to this new land, were the opposites of the expelling forces: freedom of religion, the possibility of participating in political pursuits, the seeming absence of a functioning rigid class structure, the availability of free basic education, the opportunity to rise above their families' accustomed place in life and the greater possibility to find employment. For Italian immigrants, some, but not all, of these were involved in the decision to emigrate; clearly, the most important was the economic factor: the work opportunities and the chance to earn a salary to support themselves and their families. Even though by American standards a typical wage earned by an Italian immigrant was miserly, it was far more than he could earn in Italy at a similar position.

Accordingly, although a people with a heritage of working the soil for a livelihood, Italian immigrants moved into large metropolitan centers such as New York City, where they began their ascendancy as the city's largest ethnic bloc and in the process became indelibly identified with Little Italy neighborhoods for generations. The pattern was repeated in large urban centers such as Philadelphia, Baltimore and Boston. Nevertheless, for the fortunate few from the outset, the lure of the land was fulfilled. To own the soil in which to build their homes, to raise their families and to grow familiar fig trees and other citrus fruits and vegetables was the dream that impelled them to bypass crowded and stench-filled tenements in congested and teeming cities for the more sparsely populated countryside—the term suburb was not yet the popular designation. Thus it was that a handful of Italian enclaves on Long Island began to emerge by the early part of the twentieth century in both Nassau and Suffolk Counties, including, among others, Inwood, Westbury, Glen Cove and Port Washington in Nassau and Patchogue and Copiague in Suffolk.

A PROLETARIAN PEOPLE

Long Island's Italian immigration configuration likewise shadowed a familiar pattern of chain migration; namely, it followed the journey of family members and village pioneers whose primary focus was to search out work and settlement possibilities. Italian immigrants were decidedly a proletarian element, a fact borne out by official census figures of the period— they possessed a lesser amount of capital per individual than virtually all newcomers of that era. Another example from the New York state census of 1915 indicated that, in Patchogue, the overwhelming majority of Italian Americans were distinctly in common working-class occupations. The same census records demonstrated similar findings in Westbury, where 136 of 275 Italian male residents were in proletarian occupations. Unlike the enormous opportunities inherent in New York City in various fields such as construction, the garment industries and the printing trades, Long Island possessed few major industries, specifically only a handful, including sand mining, horticulture and the railroad industry. By the early 1900s, Italian immigrants and their children were becoming essential in all these businesses and, in some instances, continued to be important factors over the course of succeeding generations. Although frequently linked with other causes, the

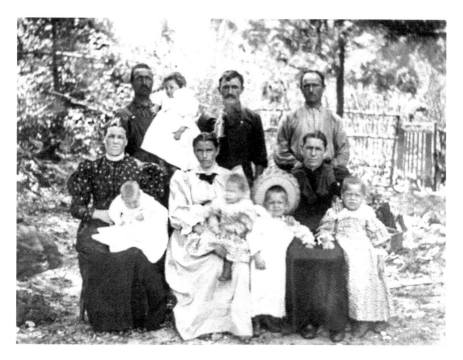

Italian immigrant workers and families in Roslyn, 1900.

need to find a job was, of course, a compelling operative immigration factor with all newcomer groups, but for Italians, it was the dominant causative immigration factor. Departure from their homeland was not prompted by a desire to escape religious or political persecution—it was prompted by the opportunities to earn a living for themselves and their families. This was so pervasive a motivation that it was expressed in a common saying of the period: "Italy was the land that gave you bread." Recalling that early period, one Italian immigrant to Westbury confessed he was given the epithet "work" because of his constant inquiry about job opportunities. Finding work was the guiding principle for most of the first wave of Italian newcomers whose goals were to earn money in America and then return to live in Italy, as many did.

THE LONG ISLAND RAILROAD (LIRR)

During the 1890s, Italian immigrants began to emerge as the leading members in the Long Island Railroad workforce that enabled that transportation system to expand extensively. The railway was the product of an amalgam of several lines present in the area, which, by 1900, was undergoing technological improvement, enlargement and electrification. The organization that in the second half of the twentieth century became the nation's foremost commuter line was then a much shorter conveyance system that served somnolent little farm villages set in pastoral surroundings, primarily in central Nassau County and western Suffolk County. Desirous of growing their business, railroad administrators concluded that passenger business would improve by the extension of branch lines into the more populous north and south shores, along with lengthening the system into Suffolk County. This required the labor of thousands of people of whom Italians formed the largest single ethnic group. They undoubtedly were organized by the padrone system that accompanied every immigrant community. In Italian American settings, the individual padrone functioned as a paternalistic employment agent. Typically Italian born, and therefore familiar with language and customs, he recruited workers with vague promises of jobs and lent them money to cover food, transportation costs and work-site shelter—usually a flimsy building that offered rudimentary dormitory arrangements. Most padroni had earned a disreputable reputation for exploiting their fellow immigrants, providing jobs at meager salaries and overcharging for services. These dubious middlemen were part of the Italian immigrant scene from the outset, supplying labor for mines, factories and construction projects among other ventures.

That the padrone system was present within Long Island's Italian labor setting is readily reflected in newspaper accounts, which were replete with references to its role in supplying the railroad line with thousands of Italian workers from the 1870s into the early 1900s. An example cited by one newspaper related the activity of railroad agents who scoured the Italian quarters of New York City and Brooklyn in 1877 in order to assemble a workforce of three hundred men who were immediately put to work for the Long Island Railroad. Unfortunately, considerable hardship attended this type of employment, including long hours for low wages, housing in flimsy shanties, working under extreme weather conditions and other difficult situations. Nor was this the extent of exploitation that was compounded

frequently by unconscionable padroni who deferred or downright refused promised payment to workers. Against this corrupt behavior, Italian railroad workers sometimes retaliated, as in 1894, when dozens working at the Wading River site in Suffolk County went out on strike, thereby succeeding in influencing hundreds more of their compatriots to join them in a work stoppage that completely paralyzed the railroad's construction operations until their grievances were corrected.

One of the more fascinating aspects of the Long Island Railroad–Italian nexus revolved around farming and, accordingly, stands as a refutation of the common conception that, notwithstanding their heritage, Italian immigrants were deserters of the soil. Husbandry, of course, had been a major feature of the Long Island economy for centuries and endured in its significance late into the nineteenth century. However, due to a combination of factors, such as ravaging forest fires and remoteness when compared to the more populated settings bordering the bays and harbors, the center of the island came to be regarded as poor, infertile and only capable of yielding indifferent crops. This perception had serious consequences for the Long Island Railroad, which saw an increase in the regional population as necessary to ensure a customer base. To that end, the railroad endeavored to promote the area as a desirable place to farm and grow fruits and vegetables to supply growing demands from New York City. Proximity to the urban center rendered the idea meritorious because of the short driving distance from Long Island to the metropolis. To further demonstrate the feasibility of fruit and vegetable farming, the railway system established two experimental farms, which provided palpable evidence of the concept. One of these was in Medford, and the other was on eighteen acres "of the worst looking scrub oak near Wading River" close to the recently completed railroad extension. If this sparsely populated and dismal looking soil could be converted to productive truck farming land, it would go a long way toward demonstrating the validity of truck farming, while also boosting the railroad's economic viability.

To undergo this transformation, in 1905, the railroad brought in Italians who not only were available but also were acquainted with this type of agricultural work in its Wading River farm site. In a short period of time, the Italians cleared the land of trees, eliminated stumps and rid the grounds of debris and other impediments. They then started to plant vegetable and fruit seedlings that did indeed produce the desired crop. They also proceeded to build a barn and a chicken house, dig a well and

fence off the property. In short, they not only impressed observers with their work ethic as they performed farming duties but also demonstrated that the seemingly useless land could be worked productively for growing fruits and vegetables.

The Horticulture Industry

Italian labor was significant in Long Island's reputable nursery industry, which had long enjoyed an enviable status in the eastern part of the United States. For many years, estate owners and developers of major sites from Rhode Island to Virginia hired Long Island's horticulture entrepreneurs to improve and beautify their landholdings. Westbury's Hicks Nursery Company, operated by descendants of the venerable Hicks clan—a pioneer Quaker family who had left an indelible imprint as a prototype of rural America in the Long Island of the nineteenth century—was a case in point. In the early 1900s, the majority of its employees were Italian immigrants, largely from the towns of Durazzano, Nola and Saviano, near Naples, who seemed to possess uncannily green thumbs and obviously were sought after by horticulture industry entrepreneurs. A meticulously cultivated Hicks family document provides a revealing picture of the labor status of Italians in the early 1900s. Thus, in 1906, Hicks Nursery employed fifty-five workers, thirty-five of whom were Italians who were paid an average of fifteen cents an hour for ten-hour workdays, six days a week. Company records of 1906 shed light on workers' salaries, which averaged $438 a year. Deeming these wages unsatisfactory for the labor-intensive work, the Italian employees went on strike that year and remained idle until five days later, after the firm agreed to a slight improvement in salaries—unfortunately, the Italian strike leader was discharged.

Sand Mining

Italian immigrants were also a major component in Long Island's important sand-mining industry. In the 1860s, sand—which had been concentrated in Port Washington, on Nassau County's North Shore, from thousands of years of quartz fragment accumulation—gained recognition

as an ideal element for mixing concrete and thus began to be mined for construction purposes. By the 1890s, the demand for the valuable basic raw material flourished as New York City construction companies ordered large amounts of Port Washington sand to be shipped seventeen miles to the city on dozens of barges in order to build sidewalks, skyscrapers, subways and other infrastructure. These included the Chrysler Building, the Empire State Building, the World Trade Center, the Queensborough Bridge, the FDR Drive and the West Side Highway. It has been estimated that 90 percent of the concrete used in New York City came from Port Washington. The lucrative industry, Nassau County's largest business, would become the single-greatest source of revenue for the Long Island community. Benefitting from all this construction activity, Port Washington's sand mine operators happily expanded their operations and sought more low-cost laborers—increasingly, Avellino-born immigrants and their children. At one point, there were eight hundred workers living in barracks at the sand bank who provided the requisite labor force to push wheelbarrows to waiting schooners and move sand through giant conveyor belts tunneled under West Shore Road to waiting barges.

Toiling in the sand mines was extremely laborious and dangerous work. One example was provided by a nineteen-year-old Italian American who went to work in the sand pits for fifty cents an hour in 1937: "We worked in 100-degree heat. We worked in rain and snow. We worked in all conditions." Some sand deposits measured over six hundred feet in depth, requiring miners who were standing sixteen feet below the surface to manipulate the shifting and treacherous sand with long poles. Too frequently, and almost without warning, the unstable mineral spontaneously fell on workers below, injuring them or even burying them completely. Because the nature of mining was so demanding and labor intensive, it was regularly avoided by local residents, thereby opening up employment opportunities for immigrants. Furthermore, during the early stages, mining for sand was totally manual; men utilized muscle to carve sand from hilltops with shovels and move it around in wheelbarrows. For such hazardous work, sand miners received $1.50 per day in 1908.

Local entrepreneurs negotiated with padroni to bring in hundreds of Italians from New York City and house them dormitory style in either homes of padroni or company-owned shacks while charging exorbitant rents. It was not surprising that aggrieved miners resorted to a strike. They failed, however, because mine operators were able to enlist the aid of local officials, who deputized firemen to break up the strike. Finally, after

decades of exploitation, in the 1930s, workers organized a union that led to improvement of working condition and better wages for sand miners

To be sure, not all padroni were totally unscrupulous and driven solely by craven greed. Some gained respectability and became prominent in their communities. James Marino, for one, an immigrant from Avellino, Italy, operated a boardinghouse for fellow Avellino immigrants who were expected to purchase food needs from his store. Marino became an adroit entrepreneur with a keen business acumen. He acquired considerable real estate locally and also ran his own sand mine. In 1904, during the usually slow winter season when demand for sand industry products tapered off, he hired the immigrants to build a stone mansion for his family. Utilizing his own sand pits to obtain most of the necessary construction material, he also intelligently drew on the unique masonry skills of his borders to cut and shape bricks, granite and other stonework that enhanced the striking edifice. Marino's designation as a deputy sheriff in Port Washington was another indication of his influence.

Port Washington's sand-mining industry operated for more than a century, providing not only the raw material for construction but also the physical environment for desert-set films. But by the 1990s, the sand-mining era was finished, as the choice mineral was used up and the mining areas were abandoned, leaving potential environmental dangers and many physical scars in their wakes. The huge cliffs created by the years of sand dredging reached two hundred feet high and constituted a genuine threat of collapse to nearby homes. In addition to the cliffs that required stabilization, the hundreds of once lucrative acres were littered with digging equipment, decaying conveyor belts and an assortment of debris. The physical transformation led to a move to earmark the site for a state-of-the-art championship golf course and senior housing.

But it was not the end of Port Washington's sand mining story. Thanks to a group of Port Washington residents, many of whom were descendants of immigrants from Avellino and whose family members had toiled in the mines, a movement to commemorate Italian immigrants' roles in this industry developed. The notion of a memorial was first suggested by George Williams, head of the North Hempstead Town Preservation Commission. Williams contacted Leo Cimini, then president of the John Michael Marino Sons of Italy Lodge in Port Washington. The two men promoted the concept, but progress came slowly. In time, however, Cimini, himself an immigrant and a congenial man long active in community and Italian American affairs, became more familiar with and

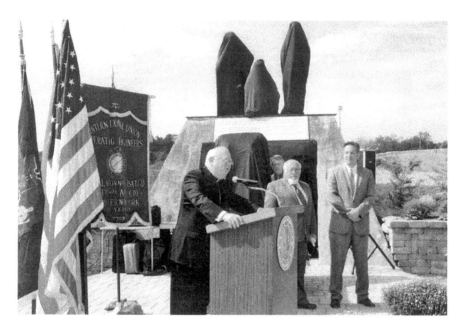

Dedication of Sand Miners Monument, Port Washington, 2011. Bishop William Murphy at dais; Leo Cimini, president of the monument committee, at center. *Courtesy Leo Cimini.*

proud of the immigrants' roles in the sand miners' story. Although he did not work in the mines, Cimini was convinced that something needed to be done to remember the history of the people whose sweat and toil had been indispensable to the industrial growth of Long Island. He gathered together a group of like-minded individuals, including retired miners, and formed a committee to raise funds to finance the memorial, which, when completed, was highlighted by a life-size bronze sculpture created by Edward Jonas and placed near the last remaining sand mine tunnel on West Shore Road. Successful fundraising efforts included large donations from wealthy people such as Kenneth Langone and smaller donations from the families of former sand miners and their descendants. In addition, the Town of North Hempstead provided the property on West Shore Road where, in September 2010, the monument site was unveiled. The final piece of the memorial project was completed in June 2011 with the unveiling of a bronze plaque that reads, "The many immigrants who came to this country brought not just hopes but a vision."

The memorial was constructed at the gate entrance of the former Colonial Sand and Stone Company. This company was started in the

1930s by Generoso Pope, an Italian immigrant whose life was a veritable Horatio Alger tale. Entering this country with barely a few dollars in his pocket, within a short time, he had become one of the wealthiest men in New York. Owner of a number of businesses—including a foreign language press, real estate enterprises on Long Island and radio station—his Colonial Sand and Stone Company was reputed to be the largest cement and gravel company in the world. Operated by his son Fortune, the oldest of three sons, after his death in 1950, it was the last company to extract sand from Port Washington quarries.

LONG ISLAND MOTOR PARKWAY

The construction of the Long Island Motor Parkway—the first parkway designed exclusively for automobiles—was another example of a project for which Italian workers formed the bulk of the labor force. Designed and financed by racing enthusiast William K. Vanderbilt, scion of the prominent and wealthy Vanderbilt family, the project was intended to provide a private venue for racecar drivers to traverse a course without speed restraints or concerns over grade crossings. The project, which commenced in June 1908 under the purview of Vanderbilt and other renowned individuals, was covered by a newspaper reporter who stated, "A spectacular effect in connection with the work was the turning loose of about 100 Italians, who prosecuted vigorously the work of the construction started by Mr. Vanderbilt." Using explosives and giant stump pullers, altogether hundreds of Italians were employed to clear the path of trees and construct a graded, banked and grade-separated highway with guard rails and controlled access suitable for auto racing.

BELMONT RACE TRACK

The spring of 1902 found large numbers of Italian immigrants among the several hundred laborers used by millionaire entrepreneurs August Belmont and William C. Whitney to clear a multiple-acre site for the erection of the world-famous Belmont Race Track. Unfortunately, as anonymous workers, they received little public attention, being

considered commonplace, nameless "pick and shovel" laborers who were otherwise conveniently ignored and consequently received little journalistic reportage. In the rare instances when the local press covered the tragedies that befell them, accounts were couched in cold, unfeeling terms in which they were identified merely by numbers and statistics devoid of personhood. Thus, when newspapers reported injuries and even fatalities sustained by Italian racetrack workers, citations referred to the victims merely by numerals. The dignity of the individual Italian was accorded no consideration, not even the courtesy of mentioning his Christian name at the time of his death.

MUTUAL AID SOCIETIES

The heyday of Italian immigration saw the creation of many ethnic institutions, such as mutual aid societies and ethnic national parishes. Virtually every immigrant cluster created mutual aid societies peculiar to their group, which sometimes limited membership to descendants from a specific town or province in Europe. These societies collected modest dues that provided a fund that would be available for needy members and their families in times of illness or death, while also promoting social and cultural events to encourage camaraderie. Several examples of mutual aid societies illustrate their meaningfulness within Long Island's Italian American communities.

Stella Albanese Society

Among the oldest was the Stella Albanese Society of Inwood, which was founded in 1897. Reflecting the concentration of Albanese Italians (who were originally descended from Albania but over centuries had become part of the Italian landscape, even while retaining Albanian language and customs), membership was limited to their descendants in Inwood. In succeeding years, prominent local Albanese Italians sponsored social events—dinners, dances and festivals—and also became involved in local politics.

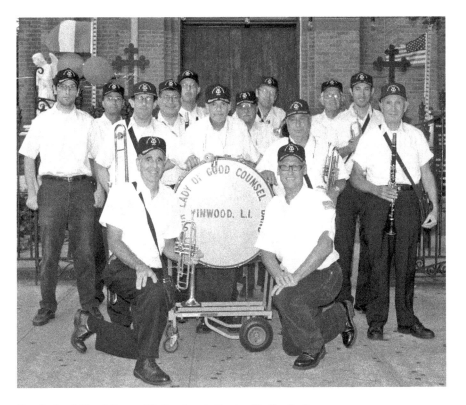

Our Lady of Good Counsel Italian band. *Courtesy Stanilao Pugliese.*

Society of Saint Rocco

Common place of origin and Italian gregariousness led to the formation, in 1910, of Glen Cove's Saint Rocco's Mutual Aid Society, whose membership was made up of descendants from Sturno, Italy. Members paid monthly dues that provided sick benefits, including doctor visits at half price and money for burial expenses. The society also began a tradition of celebrating the annual Saint Rocco Feast, while simultaneously promoting the virtues of American democracy.

Newly opened Saint
Rocco's Panetteria e
Pasticceria located in
a square near Saint
Rocco Church in Glen
Cove, 2012.

Dell Assunta Society

The creation of the Dell Assunta Society in Westbury—the oldest ongoing organization of its type in the community—is a striking example of a mutual aid society formed to benefit Westbury's Italian American population. The etymology of the Dell Assunta nomenclature is fascinating in that it was suggested by the Irish American pastor of Saint Brigid's Church in response to pressures by three Italian American groups who were descendants from Nola, Saviano and Durazzano, respectively, each of whom desired that their patron saints be designated for honor by Saint Brigid's Church. The wise pastor, realizing that the choice of any one of the three saints would surely alienate the others, proposed that since all Italians loved the Blessed Mother, they should all rally around that title and celebrate her feast, the Feast of the Assumption, on August 15. The result was the creation of a very beneficial mutual aid society that, in the era before the practice of purchasing insurance policies became widespread among poor immigrants, provided necessary aid to members and their families during times of illness and death. In addition, the Dell Assunta Society served as

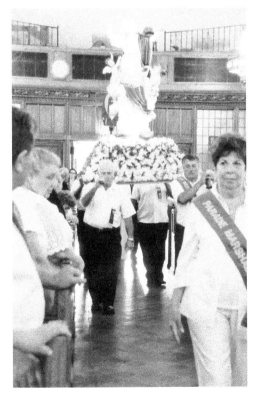

Above: Durazzano Society building in Westbury, constructed by members in the 1930s.

Left: As in the past one hundred years, faithful Dell Assunta members carry the statue of the Blessed Mother into Westbury's Saint Brigid's Church in preparation for the solemn Mass in her honor. *Courtesy Joseph Piscitelli, Dell Assunta Society.*

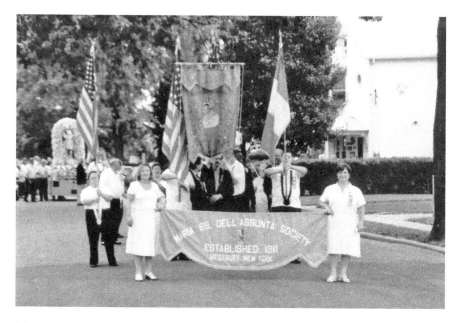

Women proudly hold a Saint Maria Dell Assunta banner during Westbury's Feast of the Assumption, 2011. *Courtesy Joseph Piscitelli, Dell Assunta Society.*

Dell Assunta Hall, built by Italian immigrants in the 1930s in Westbury.

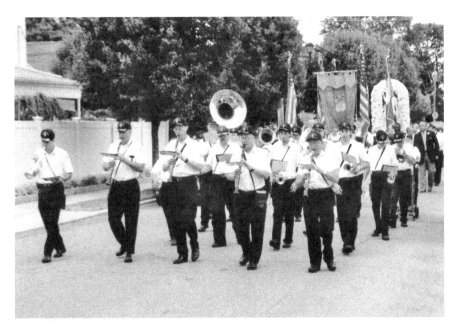

Inwood's Italian band processes through Westbury's streets during the Dell Assunta's centennial-anniversary celebration. *Courtesy Stanislao Pugliese.*

a social, recreational and religious center, as well as a mark of solidarity for the ethnic group. The realization that it has served the Italian ethnic group for over a century attests to its significance.

Order Sons of Italy in America

Other examples of social organizations formed in Long Island Italian American colonies were those of a fraternal nature, such as the Order of the Sons of Italy in America, the largest of its kind locally and nationally. A Christopher Columbus Lodge founded in 1900 in Patchogue was probably the oldest of this sort. That it flourished for a time is evident in local newspaper articles that detailed activities of an organization that sponsored festivities of a social or celebratory nature, while also promoting free evening classes to teach English to newcomers in the district's public schools. In 1920, the Glen Cove Sons of Italy Lodge came into existence and gained prominence as the fraternal order's oldest lodge in Nassau County. Other organizations created by Long Island Italian Americans

included the Italian Concordia Society and the Benevolent and Political of Bellport—a short-lived entity that focused on improving labor opportunities. Additionally, a number of Italian band groups were formed that featured Italian musicians who had learned to play their instruments in the old country. Clever employers, such as the owners of the Patchogue Lace Mills that employed large numbers of Italian Americans, sponsored these types of company bands that for decades were featured in numerous community events and feast celebrations.

Chapter 2
SETTLING IN

THE ORCHARD

By the 1920s, Italian immigrants and their children had established identifiable enclaves in several Long Island locations. Coming mostly from southern Italy and Sicily, their settlement patterns created immigration routes for others from their hometowns to follow. Thus, emigrants from Sturno, Italy, carved out a niche in a section of Glen Cove called the "Orchard," a small triangular piece of land in the southern part of the city, seven blocks square with narrow streets and modest attached homes. Nearby were wooded lands and apple orchards—hence the name—and the terminus of the Long Island Railroad along the North Shore. Many railroad workers were Italians who now were introduced to Glen Cove. Some found work as laborers digging trenches and laying concrete pipes for the town's waterworks while others were employed in constructing Saint Patrick's Roman Catholic Church in the community. Work also was to be found in the large estates being established in the area. In these occupations, they could utilize their Old World skills as gardeners, laborers and stonemasons.

BOARDINGHOUSES

The Glen Cove Boardinghouse Experience

An industrious people, Italian immigrants' earnings enabled them to purchase lots in the Orchard, where they proceeded to construct small wood-framed houses, which, far from luxurious, were nevertheless functional and accommodating. Remaining in the family with each succeeding generation on into the twenty-first century, these houses provided residences not only for immediate family members but also for boarders—sometimes numbering as many as twenty-five simultaneously. It was to the Orchard that many Italian new arrivals came at the outset of their American journey, finding their way to the Cocchiola family house. This house came to play a prominent role in community life, serving as a home not only for immediate family members but also for a sequence of newly arrived immigrants who boarded there temporarily. It was common for the children of parents who ran boardinghouses to constantly meet and intermingle with recently arrived cousins and paisani from their parents' hometown and to see these boarders come home after a day's work, purchase their mother's sauce and proceed to finish the meal by cooking macaroni. The boardinghouse experience was a temporary but important step for uprooted travelers to ward off the shock of deracination and be amid people of their own background from their own hometown who supported them during the transition. The Cocchiola family assisted many a newcomer in a variety of ways, from finding them jobs to translating necessary immigration documents and leading them through the steps necessary to become citizens.

The Port Washington Boardinghouse Experience

The importance of the boardinghouse experience was replicated in other Italian enclaves, such as Port Washington. Ralph Lamberti, born in Torella di Lombardi, in the Avellino province, first became aware of job possibilities in Port Washington because his own father had once worked in its sand pits. When he reached age sixteen in 1913, he left Italy for Port Washington, where he went to work in the pits for $1.75 per day. Like many others of his background, he was a boarder in James Marino's house, where he also was expected to purchase his meals and frequent the Marino bar. Lamberti stayed only two months before moving on.

The Piscitelli Boardinghouse in Westbury

One of the first things the Piscitelli family determined to do upon arrival in Westbury was scrape together enough money to purchase their own home, not only to make a place for family members, but also to serve as a way station for relatives and friends from Durazzano. Their goal would serve two purposes: provide assistance to newcomers within a familiar familial and cultural setting and, by renting out rooms for either two or three dollars per month including meals to the new arrivals, provide a small income for the host family. As a result of letters exchanged with relatives in Westbury, or in some instances, direct word of mouth from returned immigrants, many in Durazzano memorized the Piscitelli address and sought it out as their first destination upon entering this country. Only a young boy at the time, Dominick Piscitelli recalled the frequency with which the bedroom he shared with his brother was let out to use for new arrivals from Durazzano. John Monteforte remembered his boardinghouse experience in the 1920s when he and his father slept in a room with six other men in a Westbury house that contained three such bedrooms.

The boardinghouse experience, it might be added, served as a comforting crutch for immigrants—a place where their language was spoken, where customary food was available and where they could gain assistance in obtaining financial help. Above all it provided a reasonable approximation of the society from which they came while opening doors to the society they had entered. An accidental but interesting byproduct was that it provided an opportunity for United States–born Italian Americans to become better acquainted with the heritage of their forbears. Dominick Piscitelli, for instance, acquired firsthand information from old-country references and names his parents had long bandied about, became better informed about recent developments in Durazzano and improved his understanding of Italian language and mores.

The Patchogue Immigration Pattern

Italian (Calabrian) immigration patterns in Patchogue followed a three-step sequence: 1) taking temporary residence in one of New York City's Little Italies, 2) moving to nearby North Bellport of East Patchogue and 3) finally settling in Patchogue. This was the pattern followed by pioneer Italian American families who entered the area in the 1890s and went on to

become successful and influential in ethnic political activities and businesses. The pioneer Stephani family, for example, was conspicuous in the local construction field and in community affairs—John N. Stephani became the first Italian American to gain election to a local school board in 1913. He also gained prominence in the law enforcement field. The journey of Catherine Mailer (Mele) is another illustration of the pattern. Born in Manhattan's Little Italy (Mulberry Street) in 1889, she moved with her family to Patchogue in 1896, just after her father had completed constructing their house. She married a member of the Stephani clan who also built a home where, three-quarters of a century later, she and her son continued to live.

The Felice family, another pioneer household, became well known in the local restaurant business. In 1918, it opened Felice's, a small restaurant on Waverly Avenue, which gradually expanded with the addition of a bowling alley and later became the first restaurant in the community to offer customers an opportunity to watch television. When the place burned down in 1960, it was succeeded by "Mickey Felice's on the Bay," which met a similar fate in 1988. Nevertheless, into the twenty-first century, the Felice family name endures: Mickey Felice's Steak House on the Main is one of the most highly rated restaurants in Patchogue.

The Fuoco family in nearby North Bellport entered the locale's business affairs after immigrant Antonio Fuoco constructed a large house and store that became the heart of the Italian enclave in the vicinity. He began to thrive financially by selling grain and feed in the 1890s to local farmers, and by the early 1920s, he had expanded into the coal business; all the while, his wife ran a grocery store. Possessing a natural business sense, notwithstanding his illiteracy, Fuoco began to purchase real estate and leased out buildings. Son Louis Fuoco operated bus routes in the area that had contracts with several school districts to transport schoolchildren. Into the twenty-first century, Fuoco family members continue to operate one of the more important insurance companies on Long Island.

COPIAGUE

As we have seen, Long Island's Italian American history is largely a story of southern Italian immigration and movement, a story in which northern Italians played an inconspicuous part. One notable exception, however, is that of the Suffolk hamlet of Copiague, where substantial numbers of

northern Italians came to live in the late nineteenth century. Copiague was a small, sparsely populated settlement, originally known as South Huntington, that was tucked away in the southwest corner of the county and snubbed by better-known and more upscale towns in the vicinity. As late as 1893, it boasted of only thirteen houses situated on its main road. However, there were signs that changes were in the offing, as old homesteads were sold and divided into smaller plots. A few Italians began to settle there in the 1880s, including Dominic Botta from Genoa, Italy. He and his son Joseph were the first in the area to use a steam gang plough to work fifteen acres a day and deliver two vanloads of corn into New York City markets daily. By 1912, Botto had become immensely wealthy, and his holdings soon totaled three hundred acres. The lands were sold to New York State, which developed them, and they eventually became part of the famous Bethpage Golf Course and Polo Grounds.

Giovanni Campagnoli and Marconiville

Giovanni (John) Campagnoli was the catalyst for further Italian settlement. As a wealthy northern Italian, educated as a graduate mining engineer at the University of Bologna (where he was a classmate of famed inventor Guglielmo Marconi) and owner of a business in Italy, Campagnoli was in many respects an atypical immigrant. Furthermore, it was while he served in Italy's diplomatic corps in the United States prior to World War I that he became acquainted with Long Island. His acquaintance led to his interest in purchasing Copiague property and to the conscious development of the Long Island Italian enclave he dubbed "Marconiville," in honor of his former classmate. On two occasions, Campagnoli was able to entice Marconi to visit the town named after him and where he was acknowledged by local Italian inhabitants. Campagnoli operated a real estate business that aggressively promoted the sale of lots in "Marconiville" within various Little Italies in New York City and beyond. This was the background to the influx of the Tassinari, Giorgini and Bernagazzi families who were born or descended from northern Italy's Emilia-Romagna's province and who originally settled in Manhattan's Little Italy (Mulberry Street) and Belmont of the Bronx before they relocated to Copiague. For these northern Italians, the Long Island suburb held out the promise of owning their own lands and approximating the kind of lifestyle associated with a more comfortable class.

This cast-iron grill spells out Marconiville, the unofficial name for a community in Copiague.

Southern Italians also came to settle in Copiague especially since Campagnoli promoted his real estate enterprise in New York's working-class Italian American areas. An interesting example of how he did this was by enlisting a saloon proprietor's aid in Brooklyn's Italian Bushwick section because of the merchant's frequent interaction with local people, who were enticed to place down payments on lots in "Marconiville." Unfortunately, many of them were unable to complete the purchases because of the onset of the Great Depression and, thus, lost their investments. The southern Italians who did settle in Copiague found menial jobs in the vicinity in such projects as the construction and paving of Merrick Road and in the Brooklyn Water Works in Massapequa, which was designed as a reserve water supply for New York City. This was typical "pick and shovel" physically demanding work in contrast to northern Italians, who commuted from Copiague to New York offices and businesses.

Thus, a social class chasm existed between Copiague's southern and northern Italians. The former were poor, less educated and content with simple social activities, whereas the better-educated and wealthier northern Italians possessed dissimilar interests and tastes. The social life of the gentry

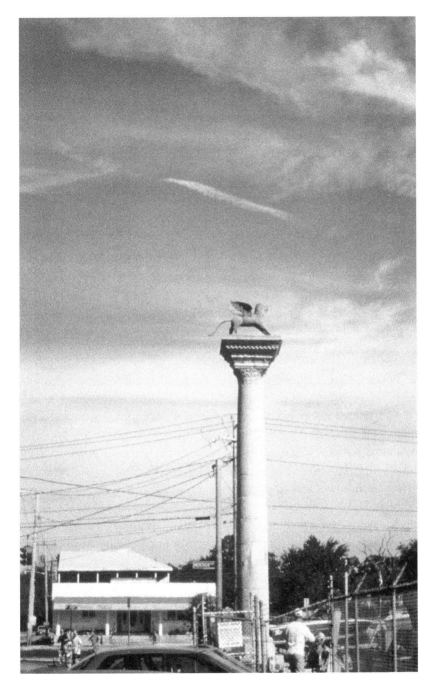

A winged lion perched above a pillar on Montauk Highway between the towns of Copiague and Lindenhurst evokes the *Lion of Venice* sculpture in Venice, Italy.

Guglielmo Marconi visits Marconiville (Copiague) named after him, circa 1916.

class, as typified by Campagnoli, is an example. He lived in a magnificent home that featured traditional Italian architectural designs, including dazzling terrazzo floors made from imported tiles and expensive classical trimmings. The Campagnolis frequently hosted the more elite upper-class members of society—a group that embraced Italian professors, important members of Italian nobility and newspapermen. Parties hosted by the family revolved around genteel and sophisticated activities such as listening to piano recitals and operatic arias. The family also partook of notable cultural events that required traveling to New York City to attend the Metropolitan Opera House and provided college education at prestigious universities for the Campagnoli children. Surely this was not the typical poor, uneducated Italian immigrant style so characteristic of the masses at the time.

Chapter 3

RELIGION

One of the hallmarks of ethnic group socialization was a commitment to transplant traditional religious practices—those with which they were familiar and preferably in their native language—those customs that afforded reassurance amid a setting that was often strange if not outright hostile. In commenting on the wrenching experience of immigration that pulled one away from familiar supports and bulwarks, historian Oscar Handlin succinctly but elegantly emphasizes the foremost role religion played in immigrant life: "A man holds dear what little is left. When much is lost, there is no risking the remainder."

For most Italians, but certainly not all, religion was expressed in terms of Roman Catholicism. As an institution, the Catholic Church enjoyed a singular position in Italy because of the historic religious and political function of the Vatican, the headquarters of the church, in the center of Italy. Furthermore, for much of its history, the church was Italy's official religion. Nevertheless there was also the reality that, for southern Italians in particular, Catholic communal practice was described as a folk belief system. It was a religious approach that encompassed official Roman Catholic values along with other tenets that were unacceptable to the church. Accordingly, less attention was paid to scrupulous adherence to church laws and doctrine while greater emphasis was placed on devotion to saints, most especially the Blessed Mother. Entering this country during the Americanist phase of Catholic Church history that found the American Catholic hierarchy stressing assimilation of non–English speaking newcomers whose religious

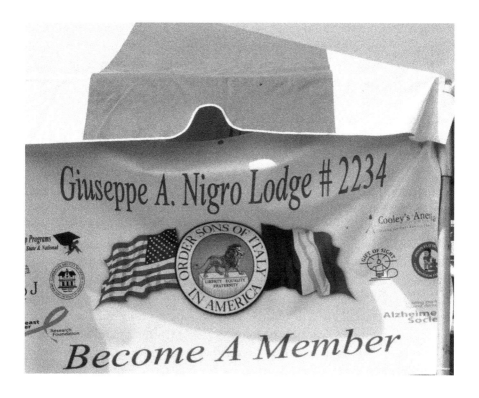

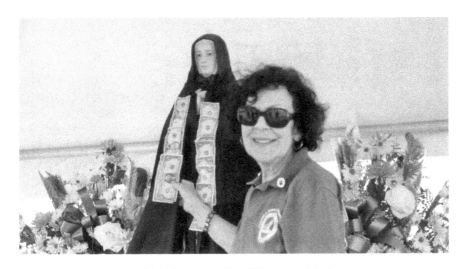

Above: Pinning bills on sashes flowing from a statue of Mother Cabrini at a feast in her honor in Brentwood, 2012.

Left: Giuseppe A. Nigro OSIA Lodge, cosponsor of Mother Cabrini Feast in Brentwood announces the many charities it supports.

Opposite, top: Our Lady of Mount Carmel Association marches a statue of Blessed Mother the through the streets of Franklin Square.

Opposite, bottom: A Giuseppe A. Nigro Lodge banner recruits members for Sons of Italy at the Mother Cabrini Annual Feast in Brentwood, 2012.

Our Lady of Mount Carmel organization of Franklin Square in procession, 1980.

practices seemed at variance with the predominant—that is, largely Irish American—model. Catholic assimilation of new immigrants posed a formidable challenge. Struggles over ethnic religious influence resulted in a partial compromise that led to the emergence "of national parishes"—an accommodation that recognized the uniqueness, nationality, language and culture of specific parishes in ethnic neighborhoods. These parishes served as mother lodes of ethnic cultural patterns, such as the promotion of particular saint devotions. These developments, while common in large urban centers, also operated in Long Island suburbs.

DE FACTO AND DE JURE ITALIAN ETHNIC PARISHES

The most significant finding uncovered by a study of Italian immigrant interfacing with Long Island Catholic religious institutions is that there existed a variety of experiences, thereby affirming the pragmatism that characterized their religious expression. To be sure, there was some defection from Catholicism; however, in the main, they remained

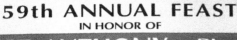

59th ANNUAL FEAST
IN HONOR OF
ST. ANTHONY DI PADOVA

UNDER THE AUSPICES OF

ST. ANTONIO DI PADOVA
BENEVOLENT ASSOCIATION OF LONG ISLAND

† ENRICO FAZZINI, *Honorary President*
† SANTA FAZZINI, *First Lady*
EMEDIO FAZZINI, *President*

5 DAYS OF FEAST
June 9, 10, 11, 12, 13, 2000

at ST. ANTHONY'S CHAPEL
90 MEACHAM AVENUE
ELMONT, LONG ISLAND, N.Y.

FEAST COMMITTEE
EGIDIO FERRANTE, CHAIRMAN · GINO COLATOSTI, VICE CHAIRMAN

DOMENICO APICELLA	ANTHONY ENRICO CORE	ANTONIO LIBERATOSCIOLI	PETER REALI, SR.
ARMANDO BELLI	AMERICO CORTINA	DOMINICK LEVA	PETER REALI
† AMATO BOTTONI	ANGELO CORTINA	AUGUST MARIANI	MICHAEL REALI
LOUIS BOTTONI	ANTHONY CORTINA	EDDIE MARIANI	ANGELO REALI
JOSEPH CARDINO	EMIDIO FAZZINI	NINO MARIANI	MARIO REALI, SR.
GINO CASAGRANDE	DR. ENRICO FAZZINI	JACK McKENNA	JOHN RECINE
JOHN CASAGRANDE	JOHN FAZZINI	ANDY MONTONI	PAUL RECINE
DOMENICO CAVALLI	AL FERRANTE	PETE MONTONI	DOMINICK STAGLIANO
VICTOR CAVASINI	ALBERT FERRANTE, JR.	GIUSEPPE NANIA	RICHARD SMITH
JOHN CERVINI	ANGELO FERRANTE	FRANK ANTHONY NANIA	UMBERTO TAGLIENTE
WARREN CERVINI	AMERICO FERRANTE	SANDY NICOLIA	PAUL TESTA
ARMANDO CINELLI	JIMMY FERRANTE	EGIDIO PALUSCIO	ENRICO VERRELLI
JACK CONTARDO	DR. MARIO FRACASSA	JOHN PAOLO	GUIDO VITI
	LINO FRATARCANGELI	PAUL REALI	

TREDICINA TO ST. ANTHONY... JUNE 1, to JUNE 13, at 8:00 P.M. in CHAPEL
UNDER THE DIRECTION OF FATHER SALVATORE RIZZI and TERESA REALI

— PROGRAM —

FRIDAY, JUNE 9th at 7:00 P.M. – Opening of the Feast, the Blessing of the St. Anthony Bread.
8:00 P.M. to 11:00 P.M. – Emozioni Orchestra, Master of Ceremony Donato Funzino, with John Francino, Terry and Anna Maria

SATURDAY, JUNE 10th at 7:00 P.M. – Emozioni Orchestra, Master of Ceremony Donato Funzino, with
to 11:00 P.M. – Sal Conte, Valeria, and Anna Maria

SUNDAY, JUNE 11th at 9:30 A.M. – Mass at St. Vincent De Paul Church, Grand, Followed by our Procession for St. Anthony with our members & friends.
5:00 P.M. to 11:00 P.M. – Emozioni Orchestra, Master of Ceremony Donato Funzino, with John Francino, Luciana, Anna Maria.

Left: Saint Anthony Feast proclamation in Elmont.

Bottom: Rockville Centre bishop James McHugh and Father John Titone, pastor of Sacred Heart Church in Island Park at Long Island's San Gennaro Feast, 1999.

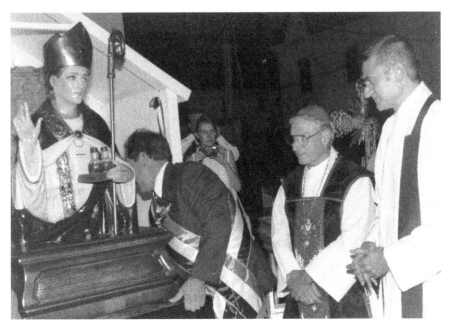

Catholics, although within their transplanted definitions of Catholicism, including minimal dogmatic integrity and casualness regarding church rules. While these attitudes cast them as poor practitioners of their faith compared to more predominant Irish Catholics in their midst, their attachment to their religious roots encouraged them to remain within the fold, either by absorption into extant Catholic parishes where pastors were empathetic and accommodating or by creating their own diocesan-approved but nevertheless de facto ethnic parishes or actual nonterritorial national parishes. Whereas urban Catholics normally worshipped in local churches geographically proximate to their own residences, those who worshipped in national parishes frequently went to churches that were not necessarily within the immediate geographic community. These de jure national or ethnic parishes operated with diocesan hierarchal approval and provided a religious experience that was expressed in a liturgy, a language and with customs peculiar to a nationality or language group. Alongside these parishes were those that, while not officially designated as national parishes, nevertheless functioned in similar fashion largely because they were situated in distinctive ethnic neighborhoods. These were de facto parishes. I will review several instances of Catholic Italian American life on Long Island, ranging from accommodation parishes to de facto and de jure parishes.

Accommodation in Saint Brigid

At the time when Italians began to settle in Westbury, the community boasted of Saint Brigid Church, founded in 1856 and regarded as the oldest Catholic parish in Nassau County. Founded by Irish immigrant farmers and staffed by Irish pastors, the Hibernian-leaning congregation would be challenged by the Italian influx. Irish pastors were hard-pressed to deal with newcomers whose tradition and background differed markedly from those of the Emerald Isle. The challenge was met by adjustment and by steps taken to make room for Italians, which effectively constrained efforts to start an Italian ethnic parish. While they worshipped in Saint Brigid's Church, Westbury's Italians nevertheless insisted that their traditional mores and customs be acknowledged and given recognition, most notably in the matter of respecting the position that should be accorded to their time-honored saints, specifically with a parish-sponsored feast. Italian immigrants in Westbury came from three Italian towns, each with a strong attachment to

its own saint. For example, Saint Vincenzo is the patron saint of Durazzano while for Saviano, it is Saint Giacomo, and for Nola, it is Saint Felix.

Representatives from each group sought the pastor's acknowledgement that their own hometown saint be recognized as the figure around which Saint Brigid would hold a parish-supported feast. Their requests presented a dilemma. If the pastor opted for any one of the three—Vincenzo, Giacomo or Felix—he would alienate the other two. In concert with Nicola Piscitelli, an Italian American community leader, Saint Brigid's wise Irish pastor, Father McGinnis, suggested that they should settle on a saint with whom they all could identify, such as the Blessed Mother. This therefore was the interesting genesis of one of Long Island's most memorable Italian feasts.

Accordingly, Westbury's Italians decided to hold a feast celebration in honor of the Blessed Mother: the Feast of the Assumption on August 15. Beginning in 1910, this festival lays claim to being one of the oldest continuous feast celebrations in the New York metropolitan area—even older than the better-known Saint Gennaro's Feast in Manhattan's Little Italy. The saint feast-day solution was also the spur to the founding of Westbury's Dell Assunta Society, the mutual aid society that has sponsored and organized the event for over a century. Prior to World War II, this was the standout feast in the Westbury area. It began with the celebration of High Mass in Saint Brigid's Church and was followed by a sparkling procession of smartly dressed men in white trousers and dark jackets and women wearing sky blue capes marching along Post Avenue, the main thoroughfare, to the feast site. Attending crowds numbered into the tens of thousands.

Saint Peter of Alcantara

Established in 1900, Saint Peter of Alcantara served Port Washington's Catholics during the time Italian immigrants were entering the community. Here also, Italian Americans eschewed the desire to form an Italian ethnic parish and accepted Saint Peter's accommodation approach, a decision that was not a reflection of apathy. In fact, there was a plethora of ethnic activities and organizations, including extensive coverage by the local press that indicated one of the liveliest ethnic communities. Early in their Port Washington tenure, Italian Americans began to celebrate their heritage by creating societies and organizing feasts in honor of Our Lady of the Assumption and Saint Anna. The latter had special meaning to Port Washington Italians because so many had come from towns in the province

of Avellino, Italy, which claimed Saint Anna as its patron saint. By 1913, the feast of Saint Anna had become a fixture in the Long Island locus. Fascinatingly, there was a nationalistic dimension to that year's celebration in the form of a spectacular fireworks demonstration depicting the bombardment of and later Italian troop landing in North Africa during the Italian-Turkish War (1911–12). Another fireworks demonstration celebrated Guglielmo Marconi's wireless invention. Interestingly, the pyrotechnic displays elicited complaints because of the noise and clamor rather than praise for their ideological content.

Our Lady of Good Counsel

One of the earliest examples of a de facto Italian parish on Long Island came to be found in Inwood, where substantial numbers of Sicilians, Calabrians and Albanian Italians settled in the 1880s. By 1900, Inwood's Italian population, overwhelmingly Catholic, numbered 204, a figure that would jump to 752 in 1910. Saint Mary Star of the Sea, located in a neighboring town and the nearest Catholic Church, was led by Irish American Father Herbert F. Ferrell, a pastor who, fortuitously, was sensitive to the immigrants' needs and provided Sunday school instruction for their children. But he did more—he helped lay the foundation for the creation of an Italian parish of Our Lady of Good Counsel in Inwood. In reality, it was a de facto rather than a de jure Italian national parish that clearly reflected the prevailing Italian culture of the community. While research regarding the prevailing relationships that existed between Irish American Catholics and Italian American Catholics stresses tensions between these two different cultural groups with dissimilar understandings of Catholicism, interaction between the two ethnic groups in Inwood was much more harmonious. The list of parishioner names from Saint Mary Star of the Sea who actively supported the creation of Our Lady of Good Counsel generously by donating funds for the tabernacle, vestments and other furnishings resembled a list of marchers in a Saint Patrick's Day parade. Moreover, Father John J. Mahon, of Irish ancestry, became the first pastor of Our Lady of Good Counsel. Succeeding him, however, was a sequence of Italian American pastors that would last for decades.

The italianità of Our Lady of Good Counsel was evident from the outset. At the formal parish dedication in 1915, dignitaries greeted the congregants—over half of whom were of Italian background—in English

and Italian. The strength of ethnicity could be seen in the record of marriages that were performed in the parish, which showed that in 1911, virtually all unions were between men and women with Italian names. The Italian ethnic hue also was manifest in the parish's creation of an Italian Holy Name Society alongside an English-language society and in the celebration of the Saint Cono Society Feast, which, as elsewhere, highlighted Italian nationalistic accomplishments. Here also, the pyrotechnic displays elicited complaints because of the noise and clamor.

Our Lady of Mount Carmel (Saints Felicitas and Perpetua)

In the waning years of the nineteenth century, a small number of Italian immigrants who had settled originally in the various Little Italies of New York City succumbed to the yearning to own their own land on which they could build homes in a more salubrious climate than that presented by congested urban neighborhoods. This was the reason that brought a number of them to East Patchogue, Bellport and Hagerman, hamlets that surrounded the better-known town of Patchogue, then regarded as the commercial and industrial center of Suffolk County. Italian newcomers began to worship in Patchogue's Saint Francis de Sales Catholic Church, a parish with a distinctively Hibernian leaning. The Irish influence was quite discernible in parish-sponsored lectures such as "The Irish Influence on the Church." It was also evident in class roster names of youngsters preparing for Communion and Confirmation. As the presence of Italians became more apparent, Father James J. Cronin, the Irish pastor, called on a young Italian priest, Father Raphael A. Cioffi, to start a new parish that would serve the needs of the newcomers.

This was the background to the establishment of the Italian parish of Saints Felicitas and Perpetua, built in the heart of the Italian section of West Patchogue, which became the focal point for numerous activities of a social and religious nature. Although it was abundantly clear that what Father Angelo Cioffi had wrought was ostensibly an Italian parish, it was not a de jure national parish; moreover, from the outset, a few parishioners were non-Italians. This reality was demonstrated by church records, which showed, for example, that 88 percent of confirmands were of Italian ancestry in 1922, while in 1951 they constituted 68 percent. During the course of Father Cioffi's tenure, the parish name was altered to become Our Lady of Mount Carmel. A prodigious fundraiser, Father Cioffi would soon be recognized

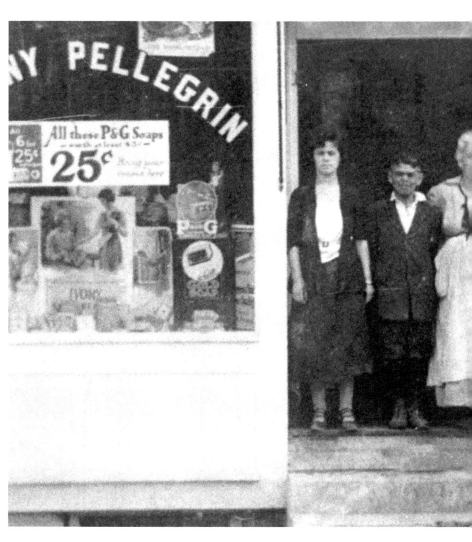

Italian American grocery store in Inwood, circa 1930.

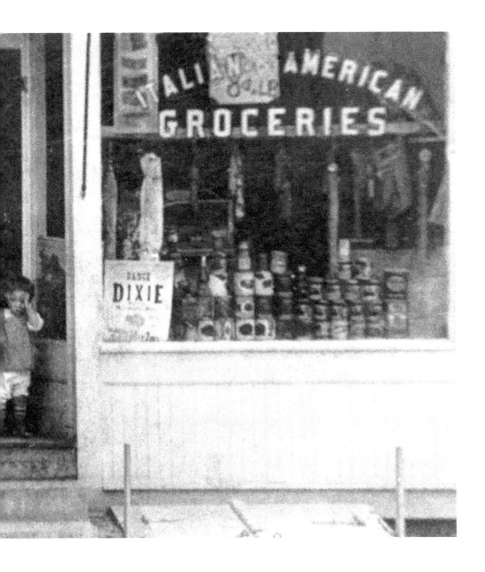

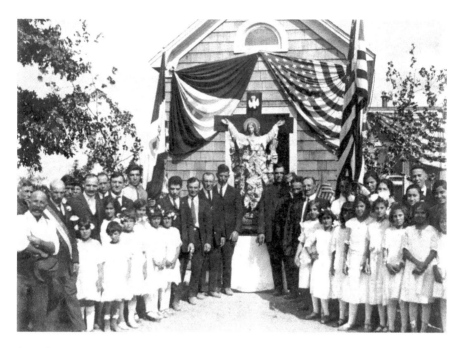

Saint Liberata Feast celebrated in Patchogue.

for his noteworthy efforts by being named pastor of Brooklyn's large Italian parish, Regina Pacis, where he built a magnificent shrine.

For over forty years, Italian American priests were regularly appointed as pastors of Our Lady of Mount Carmel—essentially paralleling the heyday of the parish's italianità. One of the most impressive of these pastors was Father Cyrus Tortora (1943–53), who literally energized the poor Italian community, exhorting people to take pride in their ethnic heritage and religion, not chauvinistically but in a positive manner, so as to enable them to overcome the negative stigma of contemporary society. The prevailing demeaning attitude was of socioeconomic derivation—one that referred to Patchogue's Italians as people on the wrong or other side of the tracks—the poor and dangerous section to be avoided. Under Father Tortora's leadership, Our Lady of Mount Carmel was host to a major Diocesan Eucharistic Congress that drew eighteen thousand people into town. Normally, a church event reserved for prestigious large city parishes, the success in bringing the activity to the Long Island church was a remarkable accomplishment, one that definitely raised the status of Our Lady of Mount Carmel. Also important in uplifting the church's profile was Father Tortora's ministry as

46

wartime chaplain to soldiers of all faiths stationed in nearby Camp Upton during World War II. That the priest's impact was meaningful is reflected in the fact that a memorial park in the community has been named after him.

Our Lady of the Assumption

The hamlet of Copiague on the South Shore, between better-known Amityville and Lindenhurst and always regarded as a deprived entity, lacked even a Catholic Church when Italians began to move into the community. Because worshippers had to travel several miles away to either Saint Martin's Church in Amityville or Our Lady of Perpetual Help in Lindenhurst, local Catholics became strongly supportive of community efforts for the town to have its own Catholic Church, which eventually led to the founding of Our Lady of the Assumption Parish. Even before definitive action was taken on the initiative, native Italian residents, recalling their homeland traditions, began to celebrate the Feast of the Assumption in Copiague. Desiring to respond to the quest for a church, the well-connected and erstwhile founder of Marconiville, John Campagnoli, offered land for the church structure in his communication with Brooklyn bishop Thomas Molloy, requesting the creation of a new parish. As a result, in 1929, groundbreaking ceremonies took place for the parish of Our Lady of the Assumption.

Despite the extensive involvement of Italian Americans, this new church was from the outset a de facto rather than a national ethnic parish, a point underscored by a diocesan loan of $40,000—a substantial sum of money not likely to be proffered for an ethnic parish. Despite the financial assistance, the devastating effect of the Great Depression on the lower-income community rendered construction of the new church a gradual development. For years congregants worshipped in a makeshift basement church that leaked constantly in rainy weather. A realistic reading of the community's demographic makeup lent credence to the impression of an Italian-oriented populace that characterized national parishes. This impression was further strengthened with the designation of a succession of Italian American pastors. One of these, Father Francis Del Vecchio, energized the community to complete the building of the church structure, even personally donning overalls and mixing cement in the effort. These heroic efforts bore fruit in 1942, when the new parish was officially consecrated. As elsewhere, Italian Americans celebrated the Feast of Our Lady of the Assumption, with strings of bright lights

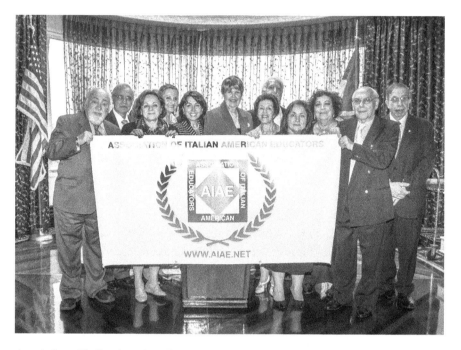

Association of Italian American Educators members join with Pres. Cav. Josephine Maietta in encouraging study of the Italian language and culture. *Courtesy Josephine Maietta.*

surrounded by streamers of vibrant colors hung across streets, booths spilling over with gastronomic favorites from which emanated pungent but wonderful aromas that drew people close, bands that enthusiastically played medleys of traditional Italian melodies and, of course, brilliant and loud pyrotechnics. Neighbors complained about the noise and potential danger of incendiary fireworks, which did occasionally spark fires in the vicinity and which later forced a diminishment of fireworks demonstrations until that aspect was eventually discontinued altogether. On the other hand, many non-Italian residents enjoyed the events and recalled their liveliness. As evident in the memories of Irish American Father Ronald Barry, the first parishioner to be ordained a priest from Our Lady of Good Counsel:

> *I remember the big Our Lady of the Assumption feasts which were very very impressive. It was like the San Gennaro's feast in New York City. It was strange to a kid like me because I had never experienced things like the parading of a statue and the big fireworks and the good odors from the*

*cooking stands with all the Italian food. I had never seen anything like that.
It was entrenched when our families moved in. It was novel to me and I
came to enjoy it a great deal.*

It was during the pastorate of Father Anthony DeLaura, the last Italian American pastor of Our Lady of the Assumption, that changes in the demographic makeup of the community became definitely discernible. Although the congregation was still predominantly of Italian ancestry, these members were largely of the second and third generations who were not strongly motivated by Italian-speaking services. Moreover, the 1950s and 1960s saw a significant influx of people into Copiague who were of non-Italian background—specifically more Latinos and considerable numbers of immigrants of Polish ancestry. By the mid-1960s, the narrow Italian phase of parish life was over; its ending was especially evident in the fading out of Italian language masses. The increase into the community by the latter two groups over the last two generations is reflected in the language offerings available in Our Lady of the Assumption—in the early part of the twenty-first century people could participate in Spanish and Polish masses in addition to English. The Italian language was conspicuous by its absence.

Church of Saint Rocco

The journey traversed by Italian immigrants and their children in Glen Cove, while similar in many ways to Italian ethnic stirrings elsewhere on Long Island, is truly unique. As in Westbury and Port Washington, Glen Cove could boast of extant Catholic parishes—Saint Patrick's Church and Saint Hyacinth—when Italians entered the community in the 1880s and 1890s. The continued ethnic-cohort increase found them predisposed to satisfy their religious promptings within the context of ancestral peasant culture, which contained an admixture of pagan folkways along with more traditional Catholic customs. In Glen Cove, even as they continued to attend weekly mass, they simultaneously promoted the cult of Saint Rocco with its lighthearted socialization. Early on, they formed the Society of Saint Rocco, named in honor of the patron saint of the town of Sturno, Italy, from which so many of them had come. Thus, although they attended Glen Cove's Saint Patrick Church, founded by Irish Americans, they hungered for religious expressions that bespoke of their Old World traditions. Faced

Italian American Citizens
Club of Oyster Bay Inc.

with an unsympathetic pastor, they were heartened by the efforts of Saint
Dominic's Irish pastor in nearby Oyster Bay, whose assistant pastor offered
services in Italian. Oyster Bay's Italian enclave had already introduced Saint
Rocco's Feast celebration into the area, which had elicited positive reactions
from the normally staid native population. "It takes the Italians to set the
pace for the ordinary Oyster Bay American. For two days and two nights
Italians have given the residents of Oyster Bay some food for thought," was
the report in a local newspaper.

When in 1909 local Polish Catholics created the parish of Saint Hyacinth
as a Polish national parish, it served as further encouragement to Glen Cove's
Italian Catholics to establish their own ethnic parish. However, it would take
many years before this pursuit became a reality because Bishop Thomas

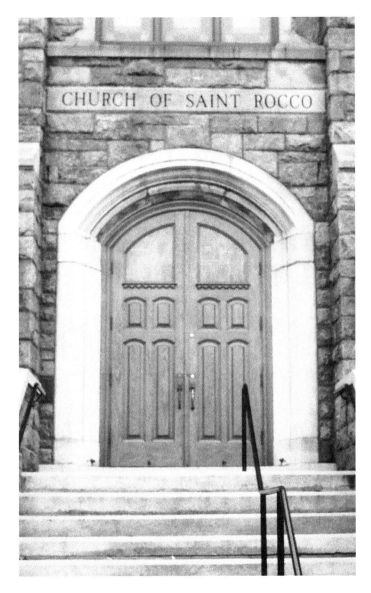

Front of Saint Rocco Church, Glen Cove, the only Italian national
parish in the Rockville Centre Diocese.

Molloy, of Brooklyn, was hesitant to approve the parish unless the promoters
could demonstrate their resolve financially. The bishop's lukewarm reception
was due, in addition, to his problems with so-called independent churches
that had emerged in the diocese. The point was that a new national, ethnic

parish must not be a further drain on limited diocesan financial resources at a time when the country was in the throes of the Great Depression. Slowly, the Saint Rocco and San Marino societies accumulated sufficient funds to purchase land for the church. In time, a temporary chapel was constructed in which masses were held on an irregular basis until diocesan authorization and legitimization was obtained. The resourceful leaders of these societies took matters into their own hands, bypassing the bishop and circulating a petition that gained thousands of signatures requesting a church of their own. Seizing the propitious opportunity of a 1936 visit to Long Island by Cardinal Eugenio Pacelli, Glen Cove's Italians appealed to the cardinal for intercession in the matter with the result that the future pope apparently interceded, because within months of the meeting Bishop Molloy acceded and approved the creation of Saint Rocco's Church. Virtually the entire Italian colony contributed to the church's fundraising drive either with cash or in-kind labor, such as digging the foundation and setting stones.

A standing-room-only crowd filled the church on Christmas Eve 1937 for the first celebration of Mass in the new edifice for which so many had labored and sacrificed. Saint Rocco was a truly de facto Italian national parish that offered not only masses in Italian but also other sacraments, such as marriages and novenas, in the Italian language. From the beginning in 1937 to 1998, every pastor was of Italian ancestry, including some with extremely fascinating careers. For example, as a young curate in a small village in Italy, Father Dante Fiorentino had developed a strong friendship with the world-renowned opera composer Giacomo Puccini. In time, Father Fiorentino wrote a biography of his friend and also fostered an appreciation for opera locally by organizing and introducing several grand operas in the Glen Cove community. During World War II, Father Anthony De Lauro, who became a captain and an army chaplain, gained widespread fame as the "front line chaplain" for his remarkable heroism in bringing aid to soldiers on the battlefront. Disregarding a wound from a minefield explosion, he ministered to eight American soldiers trapped in a French frontline pocket and helped bring them to safety.

Generations removed from the heyday of Italian immigration that witnessed a large influx from the province of Sturno, Italy, to Glen Cove, ties between the two persist. The phenomenon is illustrated by the 1980 reaction to a horrific earthquake that afflicted Sturno. Americans everywhere generously responded to fund drives to aid earthquake victims, but it was in Glen Cove that the disaster elicited the most profound reaction because so many had relatives in the afflicted area.

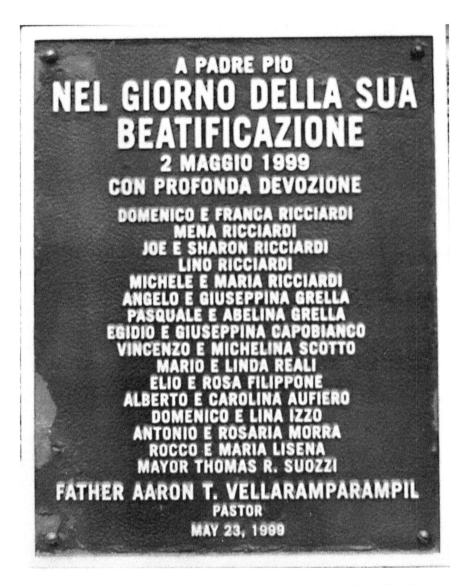

Glen Cove's Saint Rocco parishioners in support of the beatification of Padre Pio, 1999.

Protestant Italian Americans

The record shows that a small but sturdy number of Long Island Italian immigrants became Protestants, as illustrated by the following examples. Attracted by the Pentecostal movement that was characterized by less formalism and structure while emphasizing smaller congregations and more intimate relationships, some Glen Cove Italians joined that Protestant body, which featured Italian-language services. In one instance, an Italian Pentecostal lay preacher returned to his Sicilian birthplace to attempt to convert townspeople; only a few responded.

By the early 1930s, a small, informal congregation had formed as a separate religious group in Copiague. Known among local people as "Holy Rollers," they soon adopted the name of the Italian Pentecostal Church of Copiague with an Italian pastor. At the outset, services were conducted in Italian, but English became predominant and eventually even the word *Italian* was dropped from the church name.

Reverend John Agria, who belonged to the Waldensian sect of Italian Protestantism, is another example of Protestant proselytizing among Italian Americans. He came into this country from Palermo, Sicily, at age sixteen, and after graduating high school, he quickly became immersed in religious studies preparing for his bilingual ministry at Colgate University. Starting in 1932, he served Italian American Baptist and Presbyterian congregations in many Suffolk County Long Island communities. He also ministered at the Shinnecock Indian Reservation in Southampton before retiring in 1988.

Chapter 4
TRANSITIONAL TIMES IN WAR AND PEACE

The years when the United States was at war were in fact severe, testing times for its immigrant populations—intervals during which their patriotism was scrutinized and challenged by doubters who raised questions about their loyalty. Newcomers happily and continually met the challenge by conspicuously supporting American war efforts in multiple ways, but most significantly in taking up arms in defense of their adopted country. Italian Americans demonstrated loyalty to their adopted country even in the short-lived Spanish-American War. Immigrant Giorgio Alexander Minetty (Minetti) was a case in point. Possessing an Italian military background, he joined the United States Army and saw action in Indian skirmishes and in the Spanish-American War in Cuba. When the fighting ended, he, along with thousands of others made ill from malaria, was sent to Camp Wikoff in Montauk Point—the easternmost site on Long Island. There he wrote a remarkable memoir in Italian about combat action and the terrible physical condition of the ill and feverish soldiers, many of whom succumbed while recuperating on Long Island.

When Italy formally joined the Allies in 1915, some Italian immigrants returned to visit their mother country only to become enmeshed in the European bellicosity. Humbert Ianucci, from one of the oldest Westbury Italian American families, for instance, was in Italy when the war broke out and was conscripted into the Italian army; he was later killed in action.

WESTBURY

The response of Long Island Italian Americans to fight for their new country during World War I proved to be a splendid example of unfaltering support. Representing only a small percentage of the total population, they nevertheless demonstrated their backing of the war effort either by being drafted or by enlisting in the American armed forces. An impression prevailed that because of their illiteracy and lack of influence on the local draft board, many Westbury Italians were improperly classified, resulting in their induction into the armed forces in disproportionate numbers. There were also instances in which the draft board misspelled Italian names, resulting in complications years later when individuals applied for certain residential benefits. Some, such as Aniello Piscitelli, became American citizens by virtue of their wartime service. Piscitelli,

who arrived in Westbury in 1907 and was inducted into the United States Army in 1917, served over a year. It entitled him to bypass required traditional tests and acquire citizenship. Based on name identification, altogether 47, or 15.7 percent, of 309 Westburyites entered the service—a figure slightly larger than their proportion of the U.S. population.

Joseph Piscitelli, stalwart supporter and president of the Dell Assunta, addressed the audience during the society's centennial celebration. *Courtesy Joseph Piscitelli, Dell Assunta Society.*

PORT WASHINGTON

When Italy formally joined the Allies in 1915, some Port Washington Italian immigrants returned to their mother country to defend their homeland. James Villani, for example, enlisted in the Italian army and twice suffered battlefield wounds before returning to his Long Island home. That Long Island Italians were imbued with a high degree of patriotic enthusiasm was a sentiment clearly revealed in a letter written by Port Washington's Private Frank Polizzi during a respite from combat on the front lines. Its contents from the "Italian boy" so impressed the editor of the *Port Washington Times* that he published it: "I was very glad to hear that the folks at home are doing all they can to win the war. That's the spirit. We will show the world that Americans can do wonders before the war is over."

Most notable and tragic was the story of John Michael Marino of Port Washington. Scion of James Marino, the acknowledged leader of the Italian American community, John was educated in Port Washington's local public schools and later at Valparaiso University and Georgetown University. He entered the United States Army in 1918 and soon saw action on the front lines in Northern France and Belgium, where he suffered a fatal wound on November 9, 1918—less than forty-eight hours before the signing of the armistice on November 11, 1918.

COPIAGUE

As in other communities, Italians in Marconiville (Copiague) were prepared to make their contribution to the war effort, including by fighting in America's armed forces. Feeling slighted that the subject received scant attention in the local press, John Campagnoli decided to do something about it by commissioning the erection of a handsome stonework marker. Standing over two feet high, eighteen inches wide and six inches thick, the granite headstone features the names, carved in English and Italian into the gray monument, of twenty-one Marconiville residents who proudly served "their adopted country." The monument was displayed in front of Campagnoli's home until the 1950s, when it was removed to its current location in Copiague's Veterans' Memorial Park—a small green space at the entrance of the Long Island Railroad Station.

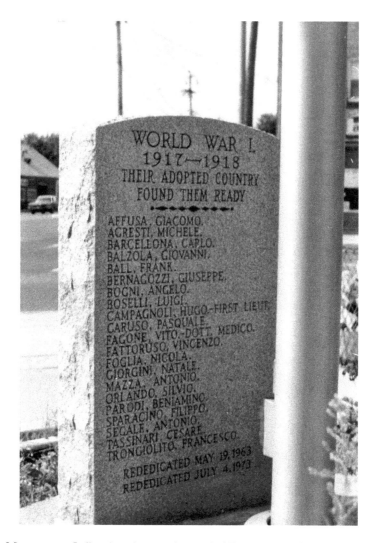

Monument to Italian American servicemen in World War I in Copiague.

INWOOD

Inwood's Italian Americans joined in the efforts to help their adopted country in a number of ways. Italians attended a rally in a local public school that featured prominent Italian American politicians who exhorted them to lend support by purchasing war bonds. They also responded generously to local Red Cross drives to aid armed forces in Italy. In 1918,

they were conspicuous in cooperating with a countywide drive to attract volunteers into the Home Defense Corps, an outfit that was expected to replace the newly active National Guard. The first volunteer quota for the enclave, set at one hundred men, was filled so quickly that another quota was recruited entirely from the Italian district. The latter unit met regularly for weekly drills and, on one occasion, broke up an antidraft riot meeting led by an outside agitator. The most celebrated Inwood war hero was Fudie (Fiorentino) Nuzzolo, a dark-haired, diminutive barber whose battlefield valor received belated recognition sixteen years later in 1934. Born in 1895 in Italy's Avellino province, Nuzzolo's life story symbolizes much about the Italian immigrant experience and the appeal of the New World: "I used to hear folks tell about America and how wonderful life was in America. I used to hear them say, 'Blessed is he who finds work in the wonderful land of America.'" Upon arrival, he became a barber in Inwood until he was drafted into the American army and saw action in the Argonne Forest in France. When his lieutenant was seriously wounded during a ferocious battle, Nuzzolo voluntarily left his shelter, ventured out under heavy enemy fire, located the lieutenant, administered first aid and then carried him to a place of relative safety. Although it took many years, Nuzzolo was acknowledged for his gallantry in action by being awarded the Distinguished Service Cross, as well as an Italian government commendation.

GLEN COVE

The enthusiasm of Glen Cove's Italian community was especially remarkable. While some, such as Patrick Maccarone, enlisted immediately after America's entry into the war and others were drafted, it was altogether an extraordinary outpouring of immigrant patriotism, as 107, around 10 percent of the city's Italian male population and many of them not yet American citizens, became members of America's armed services. The Orchard, a heavily Italian enclave, alone supplied 47 of the total while their families joined in the effort by knitting sweaters, scarfs and socks for the servicemen. The result of this activity was to impress upon native-born Americans that although the Italians were newcomers, they were nonetheless of genuine value to the American cause.

MICHAEL VALENTE

Among the Italian Americans who settled on Long Island after World War I was Michael Valente, who was born in Cassino, Italy, in 1895, immigrated to the United States and joined the army in 1916. A private in the 107th Infantry Regiment, he saw action in France that included an assault on the Hindendurg Line in September 1918. When intense German machine gun fire held up the American advance, Valente and another man voluntarily moved forward, silenced two machine gun nests, attacked a trench and killed five enemy soldiers before being wounded. Years later, the government awarded him with the Congressional Medal of Honor for this act of valor.

Six-foot-tall, blond-haired and barrel-chested Valente married Margareta Marchello, and in 1919, they settled in the seaside community of Long Beach, where they raised three children. Michael, who worked as a contractor until he became city marshal, was very involved in local veterans' groups and remained physically active by working in his garden and riding his bicycle along the boardwalk. After his death at age eighty in 1976, the City of Long Beach remembered him with a portrait

Michael Valente Lodge Sons of Italy members at a local celebration.

hanging in city hall that showed Valente wearing the Congressional Medal of Honor. The city also named a set of senior apartments after him. The local Sons of Italy Lodge to which he belonged also changed its name to the Michael Valente Lodge, and for a time, the Long Beach Library displayed a facsimile of Valente's Medal of Honor. But that was not the end of the Michael Valente story. In 2012, his grandson Ralph Maddalena launched an effort for greater recognition that met with strong approval and resulted in the renaming of the Long Beach Bridge in honor of Valente, with appropriate ceremonies attended by County Executive Edward Mangano, local Long Beach officials, veterans groups and representatives of the Sons of Italy.

BETWEEN TWO WARS

The interwar years between the end of World War I and the onset of World War II saw Long Island's Italian Americans establishing themselves more deeply into the fabric of American life. Thus, although primarily a proletarian people, they had become familiar figures in the workplace, schools and politics. Some were part of an early 1920s spurt in Italian immigration such as Avellino-born Peter Chiuchiolo, who came to Patchogue in 1923 after having served in the Italian army. Upon settling down, Chiuchiolo became a barber in the Long Island town. Others were post–World War I immigrants who joined in the expanding prosperity of the booming 1920s and were making that important transition from the humble entry stage toward a slow but perceptible climb up the economic and social ladder. Census records indicate that in addition to the laborer category, Westbury Italian Americans included a sizeable number in the ranks of barbers, bakers, mechanics, carpenters, printers, masons, seamstresses, tailors and stablemen. Even though virtually absent from the professional fields as bankers, lawyers, doctors, engineers, etc., they had developed important skills that contributed to the local economy, and their children were taking advantage of prevailing educational opportunities.

Italian Americans responded to the narrow nationalism of "one hundred percent Americanism" that flourished in the 1920s by emphasizing their patriotic contributions. In 1925, they created the Sons of Italy Lodge named after Private James Marino, the first Port Washington Italian American to die on the battlefront in World War I. Not only did

honoring a war hero serve to remind Long Islanders of Italian American patriotism, but it also was a deliberate attempt to counter the seething anti-immigrant sentiment then prevailing by vividly demonstrating the immigrant community's loyalty and nationalism. The fact that James was the son of James Marino, the wealthy mining company entrepreneur and deputy sheriff, rendered the name designation even more significant. Port Washington's Italian American population was not only growing but also branching out into various businesses and professions. For example, several members had developed construction businesses, service stations and grocery stores, and Albert DeMeo, from one of the oldest Italian families in the community, carved out a distinguished career in the field of law. He would be the first of his ethnic group to become an assistant district attorney in Nassau County.

The Long Island Railroad, the island's major industry, joined in the confident spirit of the 1920s by heralding its invitation to move to the suburbs as a summons to sane living alongside a striking oceanfront that ensured felicitous weather—cooler in the summer and warmer in the winter. The exuberant mood of the times found the modest hamlet of Copiague (Marconiville) boosting itself optimistically with advertisements promoting the community as a desirable place in which to buy real estate. One of the more interesting projects that characterized Copiague during the heady prosperous climate of the 1920s was the development of Little Venice, a real estate plan to occupy 365 acres with two thousand homes designed on the model of the famed Italian city of Venice, replete with canals, segmented arches and Florentine-style bridges. There are, in addition, two winged-lion column replicas of the originals at Piazza San Marco in Venice. Unfortunately, the beginning of the Great Depression brought an end to the captivating concept. Nevertheless, nearly a century later, these landmarks continue to soar high over Montauk Highway.

It was during the interwar years that Italian Americans became more involved in Long Island's sports and recreational activities. Many of them were active members of local sports clubs, which, while not strictly ethnic, nevertheless included huge numbers of Italian names in their membership rosters. Italian Americans became involved in the prevailing sports typical of the era—baseball, basketball, etc.—and in what was unusual for working-class immigrant children and Italians in general—golf. Introduced to the sport when they were hired by the newly opened, exclusive Peninsula Golf Club near Inwood, young Italian Americans who caddied at the course became so proficient that they regularly won caddie tournaments

This Venetian-style bridge attests to attempts at the early twentieth-century development, "American Venice," in Copiague.

defeating much older, more established counterparts. In time, the former caddies organized themselves on an adult level, participating in matches with other Long Island golf clubs and winning many games. Their success led to the purchase of their own golf course, the Peninsula Golf Course in Massapequa, which their descendants operate into the twenty-first century.

Chapter 5

ACCOMMODATING INSTITUTIONS

During this period of confidence and growth, residents of Long Island Italian neighborhoods became more visible and important in community life. This was especially true of the children—the second generation who were able to take greater advantage of opportunities for advancement. To be sure, their presence in the midst of an expanding suburban populace would tax the ingenuity of the custodians of local service institutions charged with coping with the needs of newcomers. The daunting tasks of accommodation, assimilation and integration were entrusted to the public schools, which were almost overwhelmed by the large numbers confronting them in this period. Teachers of non-Italian background were challenged, as were children of the immigrants. Not only would the latter be required to perform at a satisfactory level in their school subjects, but they also were expected to make the difficult transition from one culture to another. Language was a major issue since their parents spoke English poorly, if at all. It was not unusual for an elementary school youngster to serve as family translator. Traditional family mores from the old country that placed greater support on the formal education of males than that of females constituted another test. In instances where family economic circumstances were restricted, this cultural expectation frequently meant that limited funds would be expended for sons but not for daughters. Of course, there were many exceptions to the practice, but real educational equalizing among siblings in Italian Americans households would transpire only later, in the third generation.

Annual Columbus Day Banquet tendered by the Italian Association of Elmont, October 1937.

The ethnic theater and ethnic newspapers served as additional socializing institutions for Long Island's Italian Americans. Although less prominent than the role they played in congested city neighborhoods, the ethnic theater was nevertheless a vivid feature in suburban communities where local theaters featured touring acting companies with well-known actors and in some instances exhibited homegrown products. One example is that of Westbury's theater company, which for years staged plays in the Italian language either at the Dell Assunta Hall or Saint Brigid's auditorium that revolved around religious themes such as the life of Saint Anthony. On other occasions, people of the community were able to enjoy performances of a play written by one of their own, Joseph Monteforte, who in 1934 wrote *The Emigrant*. Performed in the Neapolitan dialect, this play revolved around the tragedy that befell an Italian immigrant. Plays that focused on the travails of immigrants were particularly well received by those who could readily relate to them because of similar firsthand experience.

Just as in the large cities, suburban Italian Americans were readers of the expansive pre–World War II Italian-language press, particularly the daily *Il Progresso Italo-Americano*. These were favorite means of communication for the first and, to a lesser extent, the second generation. By reporting on events in Italy while simultaneously covering happenings in Italian ethnic

communities in America, these newspapers served as a bridge between the Italian and American cultures. In one singular example, events specific to Italian American interests in Port Washington went beyond Italian-language news sources when, in the late 1930s, the *Port Washington News*, the community's most important local newspaper, undertook the task of providing regular extensive coverage via a column devoted entirely to the ethnic group. It was an exclusive method not to be found in any other English-language newspaper in the entire region. George W. Zuccala wrote the column, titled "Italian Review." Long active in Italian American matters, Zuccala became a strong proponent for Italian American involvement in community affairs, urging disparate elements within the ethnic group to consolidate in order to achieve more clout:

> *The Port Washington news has generously offered this space so we may expand in a movement which could develop into a highly efficient and recognized county organization of Italian Americans of professionals and businessmen to make a group directing and advancing Italian American culture and prestige.*

He also took a swipe at some Italian American leaders for assuming leadership primarily for self-aggrandizement. Zuccala's influence was not long lasting, however, because he was politically highly partisan and overly outspoken about those with whom he differed, incurring much animosity in the community. The column ceased to be published after the summer of 1939.

ITALIAN-LANGUAGE ISSUE IN PORT WASHINGTON

In its advancement of education and the Italian language, Port Washington's ethnic group was also distinctive in that it reflected the culmination of a remarkable degree of cohesion by vibrant Italian organizations in the town which put aside its differences and coalesced on the educational goal of introducing the study of Italian in the district schools. In March 1935, a petition signed by 125 Port Washington Italian American residents was presented to the school board requesting that the language be offered, stating, "It would please the Italian families in the community very much if teaching the Italian language could be included in the regular curriculum." The Italian element also said it would support a budget increase to bring it about.

The effort was in vain, however, as the school board sided with a hard-lined, unsympathetic opponent board member who contended, "If these people adopt this country they should be taught our language, and if they desire another language, it should be learned at their own expense." The critic possessed a convenient blind spot in his thinking since the school district did support the teaching of other languages, namely French and Spanish. Nevertheless the adamant school board unanimously rejected the request, declaring, "It was not essential at this time."

Although the decision rankled many, the ethnic community was not able to marshal its resources to overturn it. Given the reality that the local school boards had enormous power to influence and introduce courses into the curriculum, Italian Americans failed the test to have their voices and votes counted in these school boards. They failed, for example, to rally behind Italian American candidates to run for the school board or even to support others who were sympathetic to their cause, thereby reducing their chances of having input in policy-making evaluations. The simple fact is that Italian Americans were conspicuously absent from the school board throughout the entire period. Aside from a Dr. John Calvelli, who was appointed for one term in 1931, no other Italian name was to be found on the school board in the 1930s. Dr. Anthony Ressa ran and lost election to the school board in 1935 while in 1942, the aforementioned Dr. Calvelli ran and likewise lost in his attempt to gain a school board position. The significance of the school board as a key center of influence cannot be overestimated. In the absence of genuine home rule, since Port Washington was neither an incorporated village nor a town, the school district came closer to physically defining the community than any other government agency. The board was, in effect, "the governing body of Port Washington directly affecting the lives of the residents more than any other local unit." The absence of Italian Americans on the school board or even as candidates for those offices in this period reflects a lack of political clout.

The picture would change in the 1970s with more and more Italian Americans becoming school board candidates and more than a few winning seats. Charles Demeo was one of the most active in school matters in the later period, as he headed a taxpayer organization that inveighed against large increases in school budgets. Significantly, in 1974, the Port Washington School Board approved a petition to offer Italian-language courses in the district, explaining it was convinced there was a "solid cultural reason for offering it here." The belated action that was rendered decades after the initial foray elicited favorable comment in the local newspaper, which

asserted that it was certain to warm the heart of the Italian element, even at such a late date.

One may speculate as to the causes that led to success in promoting Italian-language education in the 1970s as opposed to failure decades earlier. One cause was the existence of an anti-Italian prejudice on the part of native-born Port Washingtonians, who traditionally controlled the school board. The aggressive actions of Italy, including the invasion of Ethiopia and association with Germany and Japan, constituted a negative factor. Another cause related to the prevailing view within the educational establishment that regarded the study of Italian as of lesser importance when compared to the study of German. In contrast, by the 1970s, the international tensions that had relegated Italy into an outcast nation were over; Port Washington's Italian American community enjoyed greater respectability in addition to having members that were part of the faculty and, most important of all, the school board, putting them in a stronger position to influence policy.

Chapter 6
WORLD WAR II

The outbreak of World War II in 1939 proved to be a supremely testing time for Americans of Italian descent. Throughout the 1930s, Italian Americans were divided between those who condemned the Fascist regime of Italian dictator Benito Mussolini—especially after Italy's 1935 invasion of Ethiopia and Italy's intensified collaboration with Axis powers Germany and Japan—and those who applauded Mussolini, notwithstanding public aversion toward him. With minor exceptions, Italian Americans who approved his leadership were more likely motivated by nationalistic sentiments rather than ideology. Simply put, it seemed that only when Mussolini ruled Italy did other countries pay attention. But with war already raging in Europe and the United States drifting closer into the conflict in the 1939 to 1941 years, the situation became not only far more complex but also more menacing. Following the Japanese attack on Pearl Harbor on December 7, 1941, and the U.S. declaration of war on the Axis powers, the status of many Italian Americans became outright alarming.

Caught up in the swirling vortex of inflamed rhetoric and hoary propaganda, the American public became intolerant of residents associated with enemy nations, thus underscoring the reality that the war years could be a wrenching experience for all Americans but even more traumatic for those whose ethnic background linked them with "enemy" nations. Compounding the problem was the 10 percent of Italian Americans who were not American citizens and thus officially enemy aliens; they, along with family members who were American citizens, experienced a curtailment of

civil rights. The remarkable thing was that despite this disturbing backdrop, Italian Americans came through the ordeal admirably, manifesting a splendid display of sacrifice, commitment and fortitude, both on the homefront and the battlefront. Italian Americans in Inwood, for example, worked in war production plants, planted victory gardens in backyards, wrote letters to boost the morale of their servicemen and bought war bonds. The scenario was similar in all the Italian enclaves. They also passed the severe litmus test of military service by flocking to the colors in numbers exceeding their percentage of local populations. The 38 out of 278 Port Washingtonians with recognizable Italian names constituted one indication that they were more than prepared to carry their share of military burden. Although no accurate record of the number of servicemen of Italian ancestry from the greater Patchogue area is available, there was one source that showed that 276 of 1,153 had Italian names.

The question of loyalty raised—namely, of whether soldiers of Italian background would accept without hesitation the mandate to fight against the land of their ancestry or seek to avoid the responsibility—was unequivocally answered—they were first and foremost Americans and would demonstrate this in action. One striking answer was voiced by Patchogue's Albert Romeo, a wartime bombardier, who responded to a query over whether he harbored qualms about bombing Calabrian towns from which his family emigrated. Acknowledging there may have been a fleeting moment in which he considered the situation of ancestral obligation, he quickly concluded that he was an American and that his first duty was to help defeat the Mussolini regime.

Perhaps the most impressive display of Italian American loyalty was to be found in Glen Cove, where it was reflected in a December 1942 Honor Roll of servicemen unveiled in Saint Rocco's Church that revealed over three hundred names of men who were members of the armed forces—many of whom appeared multiple times. It included six members of the Nigro, Dileo and Capobianco families; five from the Pascucci family; and four members of the Abbondandolo family—and this only several months into the war. Nor was it only the young who participated. Ralph (Big Ralph) Mastalio became a Glen Cove legend in his time. An immigrant, he had volunteered for the American army in World War I, and at age fifty-two on America's entry to World War II, past draft age, he left the Nassau County Police Force and dyed his hair to convince the draft board that he was a younger man. He served in the army once again, was wounded in action and received several awards for bravery. Among the many Glen Covers who performed exceptionally were Anthony Marangiello, Fred Carbuto and Victor Abate.

Marangiello, who joined the army and was stationed in the Philippines when it was surrendered to the Japanese army, was a survivor of the infamous Bataan Death March and a prisoner of war for four years. He was called on to relate the story of his survival to cadets at West Point. Marine Corpsman Fred Carbuto, who helped defeat the Japanese at the crucial Battle of Guadalcanal in 1942, even took his guitar with him in battle and wrote a hit song, "Put Your Gears on Boys," that was played on the radio. A Glen Cove street is named after Victor Abate, who was born in the city, left his post office job for the navy in 1942 and was killed after a fierce Japanese attack on the aircraft carrier on which he was a crew member.

In September 1980, West Islip, Long Island resident Anthony Casamento made national headlines when the White House announced that President Jimmy Carter had agreed to confer the Congressional Medal of Honor on him. It was the culmination of a thirty-eight-year battle waged by Casamento, who was born in Harlem, joined the marines in 1942 and engaged in the historic Battle of Guadalcanal that began in August 1942 and ended with an American victory that signaled the end of Japan's farthest outward thrust. On November 1, 1942, twenty-one-year-old Corporal Casamento, in the thick of the battle, received fourteen wounds as his unit maintained its position holding off the Japanese attack although most of his platoon was wiped out. The act of bravery seemed deserving of a high medal, but the navy refused to issue one because it found no survivors to corroborate the event. Validation came many years later after marines who had engaged in the battle came forward to substantiate Casamento's heroism, leading the navy to acquiesce by offering to award him the Navy Cross, the service's highest award—an offer the marine veteran refused, holding out instead for the Congressional Medal of Honor. By the 1960s, Italian American organizations such as the Sons of Italy and the National Italian American Foundation, along with the governors of New York, New Jersey and Connecticut and the Long Island member of Congress from Casamento's district, supported his cause. Casamento also gained national coverage by maintaining a fifty-one-day vigil in his wheelchair outside the White House. At long last, in September 1980, President Carter invited him to the White House, where in the Rose Garden the president conferred the coveted medal. A few days later, the happy president stood before some three thousand attendees at the annual NIAF dinner in Washington's Hilton Hotel to introduce Casamento, stating, "We are honored tonight by the presence of a man who personifies that patriotic spirit. Yesterday I had the privilege, an emotional privilege, of presenting him with the highest honor that our

Nation can bestow for valor, the Congressional Medal of Honor. His name is Anthony Casamento."

Long Island has remembered Casamento in the name of a Long Island Memorial Post, the Italian American War Veterans' post and a portion of Route 109 in Suffolk County. He is remembered also in the renaming of West Islip's Muncie Park to Anthony Casamento Park, which is the home of a number of athletic fields, a swimming pool and a small playground. In October 2007, at a well-attended function marked by a military honor guard, public officials, veterans groups and other community representatives, the West Islip Public Library paid tribute to Casamento by establishing a permanent display that features Casamento's Congressional Medal of Honor and other personal paraphernalia. In addition, there is a Tony Casamento Highway in Amityville.

For the thousands of Long Island Italian American veterans, the postwar period was a time to take advantage of opportunities ranging from marriage, purchasing homes and settling down to beginning careers or businesses, embarking on or expanding their educational horizons and becoming involved in community organization life and politics. A number of such instances are illustrative. Survival, not career or the future, was uppermost in the mind of Anthony Catalano of Mineola while he was serving with American army infantry forces that landed in Normandy on D-Day, June 6, 1944. The first in his Brooklyn neighborhood to be drafted, he was soon joined by two brothers. He was to endure the bitter winter Battle of the Bulge on the front lines and not only survived but also achieved the rank of sergeant before returning to civilian life. In civilian life, he had a long career as an air traffic controller, while remaining active in community patriotic activities, and he was honored in January 2013 as Mineola's "Hometown Hero."

John S. DaVanzo was another Mineola Italian American resident whose military background became the springboard for a distinguished career. Born and raised in Mineola and a Mineola High School graduate, he served in the navy, where he saw action as an officer on the destroyer USS *Glennon* that was hurling shells against the Germans during the Normandy landing. The crew was forced to abandon ship when the vessel was fatally struck by heavy German artillery. He survived, returned to Mineola, married, became the father of five children and remains active in a bevy of organizations.

There were, of course, many additional Long Island Italian American members of the service who performed heroically, such as Dominick DeLuca of Islip, who received five Battle Stars and a Purple Heart for his

CSJ project in recognition of Italian American recipients of the Congressional Medal of Honor on display in various Long Island locations.

Suozzi political dynasty members (from left to right) Thomas Suozzi, Nassau County executive; his father, Judge Joseph Suozzi; and his uncle Vincent Suozzi, mayor of Glen Cove, preparing to march in a Saint Rocco Feast procession in Glen Cove.

service, which included landing on the shores of Normandy, France, with the Second Infantry only four days after the D-Day invasion. A proud veteran, in 2010, he was the Islip Memorial Day Parade grand marshal, at which he urged everyone to reflect on all of the sacrifices made to keep our country free.

Judge Joseph A. Suozzi of Glen Cove is another example of Italian American patriotism. Born in an obscure Italian village, Suozzi, together with his mother, immigrated to the United States in 1925. They joined his father, Michele, who had preceded them to this country, arriving in 1913. Michele served in the American army, which led his naturalization—a privilege extended to Joseph. Judge Suozzi attended elementary and high school in Glen Cove and Oyster Bay. He volunteered as an aviation air cadet prior to his graduation from college and fully entered military service with the United States Air Force during World War II, becoming a navigator assigned to a B-24 bombing crew of the Fifteenth Air Force, which was based at Torretta Air Field in Cerignola, Italy—less than fifty miles from where he was born. He completed thirty-five bombing missions in Europe, for which he was awarded the Distinguished Flying Cross and the Air Medal with three Clusters.

The history of Italian American participation in World War II would not be complete without an account of female members of the armed services. Largely obscured at the time, the story became known decades later, if only partially. In October 2009, for instance, a special feature in *Newsday* paid tribute to the women who served and who were currently in their eighties and nineties. It cited the role played by Manorville's Millicent Tucci, who left college to join the navy in 1943, learned to fly an airplane in a Texas airfield and became an airplane mechanic (who endured pejorative sexist comments while working hard to keep the airplanes flying). It was in that same year that twenty-two-year-old Anne Santacroce of Sag Harbor responded to a recruitment ad by quitting her job in a bank to become an army nurse. She was present at the ferocious Battle of the Bulge in January 1945 and helped treat soldiers with mangled limbs and the wounded in a Belgian hospital with frostbitten feet. Other female World War II participants include Anne Ercolano of Nesconset, who was in the navy and who has maintained an interest in veterans' affairs, serving as president of Suffolk Sea Gulls, an organization of female navy veterans. Olive Lazio of West Islip and Sophie Visalli of Port Jefferson served as Waves in the navy. Mary Occhiogrosso of Greenlawn served with distinction in the Pacific theater of war, however, it was not until December 2010, decades later, that she was awarded four

medals for her service on the island of Iwo Jima against a background of one of the war's bloodiest battles.

The cost of the sacrifices made by Long Island Italian Americans during the war was high—every community had its share of wounded and fatalities. One of the most heartrending accounts is that of the Prianti family of East Northport, Long Island, whose five sons were in the service. The telegram that informed the family that the Normandy invasion had cost the life of one son and which was followed soon afterward by another telegram informing the family that a second serviceman son had perished was so devastating that it prompted the soldiers' grieving mother to write the chief of staff of the United States Army requesting that her remaining sons not be assigned combat duty. From that point on, the mother had masses said for her deceased sons every Friday. After the mother's death, a daughter continued to have the masses said.

URBAN TO SUBURBAN TRANSITION

I talian Americans, like all Americans, were on the move in the post–World War II period—they participated in the migration from the city to the suburbs. They were ready to exchange their tenements and railroad flats in older Little Italies of East Harlem, Bensonhurst, Arthur Avenue and various city neighborhoods for more spacious residences on Long Island. The phenomenon found them flocking not only to those locales with long-established Italian enclaves such as Glen Cove, Westbury and Patchogue but also to those towns where few of their co-nationals had settled previously, including Franklin Square, Massapequa and Selden. By 1980, they had become the largest single nationality on Long Island, accounting for over 40 percent of the population in Franklin Square, Deer Park, Elmont, Shirley, North Lindenhurst and Inwood. They also constituted over 35 percent on the population in eleven other communities and more than 30 percent of twenty-four additional towns. In short, in this vital population center in the eastern seaboard, Italian Americans' movements became the prototype of America's transition from urban to suburban dwelling.

They were everywhere in suburbia, even in brand-new communities such as Levittown, Long Island, which stands as the archetypal example of an overly sanitized community characteristic of post–World War II suburban growth. Nonexistent prior to the war, Levittown came into being in 1947 when land developer William Levitt purchased large acreage between Hempstead and Farmingdale previously used to grow potatoes to become the site of a planned community that bore his name. The Cape Cod–style community

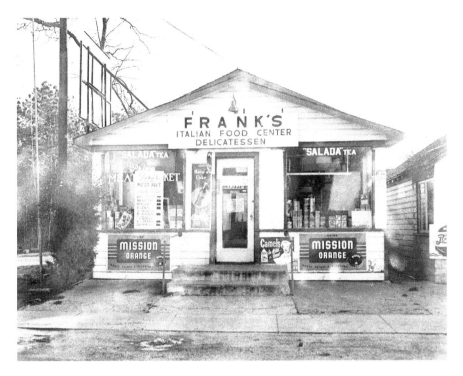

Frank's Italian Deli in Mastic-Shirley area, circa 1950. *Courtesy Shirley/Mastic Public Library.*

provided affordable individual homes designed to sell for less than $8,000 and set on a land plot featuring a slim copse of scraggly, awkward-looking trees in the backyard. The thousands of homes that were constructed in this hamlet attracted so many city dwellers that within a couple decades, it became one of Nassau County's largest populations centers, with one out of four of its residents of Italian ancestry.

In analyzing the phenomenon of transition from urban to suburban localities, the element of choice is significant; that is, those who made the transition exercised the alternative of settlement outside the congested city neighborhoods, while simultaneously satisfying an overwhelming desire to own their own homes. An impetus for moving was a housing shortage that was the result of insufficient new home construction during the great prewar depression and other priorities during wartime. Living in New York City in the 1940s meant residing in a metropolis that was experiencing such a severe lack of living space that it forced many to live in makeshift basement apartments. The housing shortage was further exacerbated by the razing of entire neighborhoods for highways like the Cross Bronx

Expressway and the Long Island Expressway. Veterans who were entitled to the GI Bill and low-interest mortgage rates were increasingly prepared to leave the city and satisfy the dream of owning a single-family home with good schools in safe neighborhoods.

For its part, the suburbs responded to the demands with massive housing developments in former potato fields so that in a short time the notion of moving to the suburbs became a viable alternative. Good, unencumbered roads and highways like Northern State and Southern State Parkways that had been built prior to World War II and that made many previously distant locations accessible contributed to the suburban attraction, as did affordable automobiles. The wartime expansion in Long Island–based manufacturing businesses such as Fairchild, Republic and Grumman aircraft companies and the Sperry Gyroscope Corporation meant many jobs within easy commute were available for new Long Islanders. These were among the precursors to spectacular population growth in which Italian Americans figured prominently.

The decision to move also represented a desire to live closer to the soil, although few Italian Americans earned their livelihood through farming on Long Island. While practicality determined settlement choices, it formed part of a larger mosaic of factors that entered into the decision, such as ease of transportation, health considerations and perceived opportunities to enter the petit bourgeoisie—to build lives more satisfying economically and socially than the ones they left behind. One historian explained: "The exodus of Italians to the suburbs was more than the result of favorable material conditions. There was an eagerness to leave the small world of the neighborhood and enter the mainstream of American life."

When the resolution to move to the suburbs was made, places of settlement often were determined by the chain migration model; namely, seeking out places where relatives and friends were already ensconced. The trek for some prospective suburbanites was the culmination of a long journey that began years before, when they placed small down payments on Long Island acreage, paying off remaining costs over the years. As finances and circumstances improved and as time permitted, they built their own homes with the aid of family members—often a modest bungalow. Even before the new domiciles were completed, new Italian American homeowners spent summer weekends in the bungalows, eventually winterizing them for year-round living.

Because suburban Italian Americans were confronted with less discrimination than their counterparts in large cities, they enjoyed the option

of choosing among alternatives. They could opt for rapid assimilation, even if it involved a negation of their ethnic roots, or they could choose to gain acceptance as Americans of Italian descent, fully conscious of a particular heritage. The latter was the choice for the majority, although there was considerable variety. Much of their activity was conducted along ethnic lines as they formed voluntary self-help organizations and social, political and religious societies, many of which continue their activities into the twenty-first century. At the same time, they also showed an inclination to join in nonethnic organizations, participating in such civic bodies as local school boards, fire departments, civic and fraternal service organizations, community clubs and hospital boards. They likewise married spouses of other nationalities and religions—studies indicate that by the end of the twentieth century, exogamous marriages were becoming the norm for Italian Americans. This developing marriage pattern did not, however, necessarily result in the diminution of ethnicity; indeed, it often served to increase ethnic identity, which could be witnessed in non-Italian spouses becoming so deeply immersed in their Italian spouses' activities that they became officers of Sons of Italy lodges. For example, although of non-Italian background, Richard Haemmerle and Stanley B. Klein, who are husbands of Italian American women, have become presidents of the Columbus Lodge and Arturo Toscanini Lodge, respectively. In addition, many of partial Italian descent have served as presidents, as in the cases of the last two presidents of the Columbus Lodge, Keith Wilson and Ed Bochynski.

While many who made the transition to suburbia were of the first generation, it was increasingly the second and third generation who manifested socialization patterns substantially similar to native-born Americans with respect to various characteristics. Thus, members of these generations soon followed prevailing educational, recreational and career patterns, attending the same schools, participating in local popular sports and striving to enter the same careers as their non-Italian counterparts.

Of the many factors that facilitated the decision to move to the suburbs, home ownership was the single primary magnet that Long Island offered to city dwellers who had endured the economic straits of the Great Depression, which had forced a deferment of the erstwhile home ownership dream. Primarily of the lower-economic class, these city tenants usually were renters residing in urban dwellings in multiple family units ranging from notorious, crowded, unventilated dingy walk-up tenements five to six stories high to three-story flats housing six families in a series of rooms connected to each other in a line (as on a railroad train) with a hallway running the

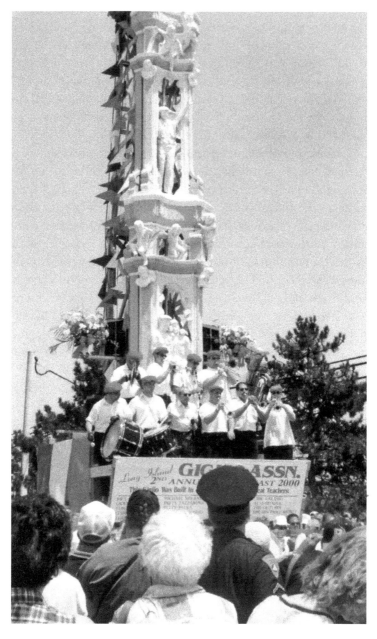

Giglio Feast features a marching band on a specially constructed tower at Sunrise Mall in Massapequa celebrating the centuries-old festival, 2000.

A scene at the popular Hofstra University Italian Festival, 2012.

length of the apartment or flat. For most, this was all their meager incomes could afford. However, as the Depression began to recede and as expanded work opportunities at higher salaries followed America's entry into World War II, many were in a better position to fulfill their home ownership dreams in Long Island's appealing terrain. They responded to real estate agents' energetic promotions in Italian language newspapers and Italian radio stations of properties for sale.

Radio station WOV, perhaps the oldest New York City–based Italian-language medium, regularly promoted its wares to a target audience. Another instance of using the air waves came in 1946, when Generoso Pope and his son Fortune Pope, already the owners of New York's largest Italian-language daily, *Il Progresso Italo-Americano*, purchased radio station WHOM and utilized well-known Italian actors and singers to promote real estate projects that proved influential in drawing Italian Americans to Long Island housing developments.

SHIRLEY

One of the more interesting home development examples occurred in Shirley, a community in Brookhaven Town, following a real estate venture started by Walter Shirley, a Scotch Irishman with an extensive theater and business background on Long Island who had served also as a campaign manager for New York City mayor Vincent Impellitteri. An astute and prescient businessman willing to take a risk, Shirley's real estate company saw the value of Long Island investment; it purchased large land acreage in the Mastic area, named it after him and skillfully marketed it to New York City residents anxious to move. The time was ripe for the suburban boom that followed World War II and so was the price—his company built four thousand homes, many of them from prefabricated sections that soon became a thriving middle-class community on the South Shore

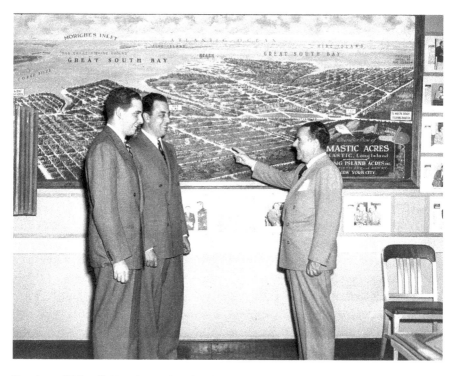

Developer Walter Shirley shows plans for development of a Long Island area to Fortune and Generoso Pope Jr., publishers of *Il Progresso Italo-Americano* newspaper. Real estate advertisements in this paper proved to be very effective and led many Italian Americans to move to Shirley in the postwar period. *Courtesy Shirley/Mastic Public Library.*

of Brookhaven Town. A master salesman, Shirley incorporated a home-building company that advertised its products via colorful brochures and television shows cosponsored with Italian Swiss Colony Wine that featured show business celebrities. For a time, Shirley used the company name "Case Mercate, Inc." in hopes of appealing to many Italian customers in the Italian-language press, only to drop the title after he learned *Case* was a misspelled translation for *casa*.

CALABRO

Among the pioneer Italian Americans to move to Shirley was Dr. Frank Calabro, a veteran Brooklyn medical practitioner, who, in the 1930s, became acquainted with the area through a friend who owned a bungalow there. In 1946, Calabro purchased a large seventeen-room house with extensive

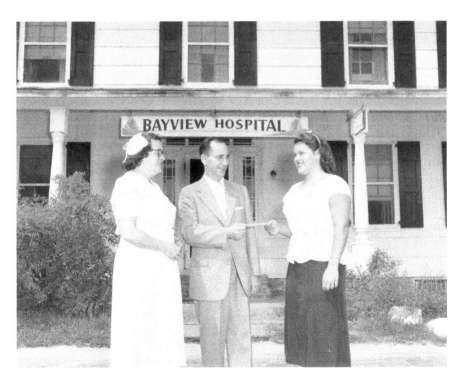

Dr. Frank Calabro Jr. in front of Bayview Hospital, operated by his father for many years. *Courtesy Shirley/Mastic Public Library.*

property surrounding it. The house was to be a residence not only for the transplanted doctor but also for his extended family—members of the DiPierro clan, as his wife was one of nine DiPierro siblings. The Calabro homestead made it possible for family members, including the Sirianis, Messinettis and DiPierros, to have a place in which to live while building homes and businesses on the property. Mike DiPierro, for instance, owned a service station business with his brother-in-law Pat Messinetti while Ben and Anita Siriani opened a delicatessen store attached to the service station and other family members operated the Red Barn restaurant that was converted out of a carriage house on the estate.

The entrepreneurship penchant likewise found Dr. Calabro utilizing his medical background to purchase the Pattersquas estate, which he converted originally into Bayview Sanitarium that offered competent care at moderate rates on a beautiful twenty-five-acre estate. In 1949, he transformed it into Bayview Hospital, a wise move in view of the fact that at the time the nearest hospital was twenty miles away. Calabro expanded the hospital facility by doubling the amount of beds in the facility in 1958 and thought of further expansion; however, with the opening up of Brookhaven Memorial Hospital in 1956, the days of the proprietary Bayview Hospital were numbered. It closed in 1982. While presiding over the hospital, Calabro simultaneously worked as a family physician. He impressed locals as a familiar respectable figure who made house calls in a gray pinstriped suit and black bag in his huge black Buick with a gleaming grille.

Cutro

The Cutro family, another post–World War II Italian American household that became a fixture in the area, owned the famous Island View Manor House, formerly a historic estate dating back to 1810. The estate had been owned by Walter Shirley, who sold it to the Cutros. In the 1950s, the Cutro family used the Manor House as a nightclub and a hotel that enjoyed popularity after trumpet player Rocky Cutro invited his friend Tony Bennett to come and perform. Bennett made appearances there regularly.

VITELLARO

The Vitellaro clan was another Italian American pioneer family that made the transition from New York City to the far confines of Long Island, when in 1947, Josephine and Dan Vitellaro bought land in Shirley for $1,625, the amount to be paid in monthly sums over five years They obtained a building permit to construct a sixteen- by twenty-foot bungalow and a garage on Baybright Drive, a dirt road that did not have electricity. The primitiveness of the setting was illustrated by the fact that Kenny and Gerri, the set of twins born to the family, could not move in with the family until electricity was installed. The bungalow was completed in 1948 at a total cost of $3,850. Their son Kenny eventually went into his own business as a general contractor.

SAN REMO

Although the small enclave of San Remo within the township of Smithtown is best understood as a section of the much larger and older Kings Park, it did have its own identity. The small locale began to attract Italian Americans in the 1920s, after Generoso Pope, proprietor of *Il Progresso Italo-Americano*, and a few other entrepreneurs purchased 195 acres along the west bank of the Nissequogue River and began selling lots mainly to Pope's readers. The San Remo appellation was a deliberate attempt to endow the community with the elegant aura associated with the namesake on the Italian Riviera. Plots of 20 by 100 acres were offered at the price of fifty dollars per lot— with a long-term subscription to his newspaper an added incentive to obtain lots. Although neither electricity nor water was readily available, a small number of New York City Italian Americans took advantage of the opportunity and began building summer cottages where they would repair to escape the summer heat. While the Great Depression caused many to lose their investments, those who survived would see their assets increase in value in the post–World War II period.

TANZI

The Tanzi family is another case in point. Louis and Frances Tanzi, who came from Brooklyn, were the first in the family to settle in the town, soon followed by Louis's brother Carlo, who in 1957 established the Tanzi Hardware and Lumber Company in Kings Park that remained in business until 1995. After the lumber yard closed, the Tanzi family built Tanzi Plaza, a shopping center at a busy intersection in town where Carlo's grandson, Tony Tanzi, continues the tradition of entrepreneurship by serving as president of Indian Head Contracting and by opening up a new hardware store in town in 2001. A large rock near **LIRR** has the Tanzi story inscribed in it.

Three generations of the Vita family, which also made its mark in Kings Park, nevertheless had their roots in San Remo. The seven sons of Manley and Angelica Vita who had participated in the armed forces during World War II served to demonstrate Italian American commitment to American democracy. Of the third generation, Charlie Vita, the most prominent clan member, had spent every summer of his childhood in San Remo at his

The story of converting a potato field into a residential suburb is conveyed in this big rock that relates the role of the pioneer Tanzi family in Kings Park.

grandfather's summerhouse, which was purchased in 1933. Charles moved to Kings Park after graduating from Uniondale High School and saw military service during the Vietnam War. Upon returning to civilian life, he demonstrated his resourcefulness in many undertakings: working as an operating engineer, the proprietor of a tavern and a real estate developer who built many homes and business establishments. Additionally, he became an active member of civic organizations, including the Father John Papallo Sons of Italy Lodge, and was honored as the Man of the Year in 2011.

MASSAPEQUA

The growth of the Italian American population in the Massapequas (Massapequa, North Massapequa and Massapequa Park) constitutes another remarkable account of urban to suburban transition. While tens of thousands of residents make up the current population in these communities, such was not the case prior to World War II—the entire area of south-central Nassau was sparsely populated—totaling an estimated 1,500 in 1910, a number that warranted the establishment of its own fire department but little more. The 1920s and 1930s brought significant changes including the creation of its own water district, the incorporation of Massapequa Park as a separate village and the debut of the Long Island Railroad station in the village. This period also led to an expansion of the public school system, although it would not a have a high school until 1955. The enormous transition from urban to suburban settlements that impacted Long Island in the decade following the end of World War II was soon reflected in demands for water in the Massapequas. Whereas the water district provided water for 184 connections in 1931, in 1955, it would be responsible for 9,090 connections.

The Italian American population upsurge in the Massapequas was so rapid that it would be only a matter of time before it manifested itself in the formation of ethnic fraternal organizations. Thus it was that in 1963, Angelo Roncallo, a Republican Party leader, future member of Congress and judge, together with Dominic Baranello, another Republican leader, and Judge P. Vincent Landi, organized the Columbus Lodge of the Order Sons of Italy in America. Attracting local men of Italian extraction from politics, business and other walks of life, its membership soared to such proportions that it soon became the largest lodge in New York State.

Columbus Lodge Sons of Italy members conduct a membership drive, September 2012 (Thom Lupo, New York OSIA president is fourth from right).

A street scene at the Italian Feast and Festival in North Massapequa, 2012.

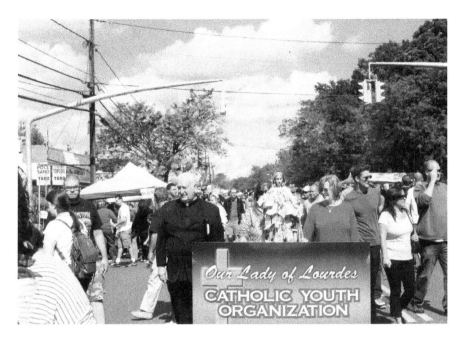

Part of a large crowd enjoying the Italian Festival in North Massapequa in 2012.

In recent years and in collaboration with the Town of Oyster Bay, the Columbus Lodge has sponsored a large Italian Feast celebration during the month of September. One of the largest events of its kind in the area, it draws tens of thousands to the many activities held in a half-mile stretch of closed streets in North Massapequa. For example, in 2012, lodge president Keith Wilson spoke on a huge stage to honor Italian Americans and to introduce numerous politicians in the area, including Congressman Peter King and United States senator Chuck Schumer.

ROCKY POINT

Located on the North Shore of Suffolk County, the hamlet of Rocky Point, although possessing certain identifiable marks of community life, such as a post office and schools that harkened back to the nineteenth century, remained a rural entity with a small population until well into the twentieth century. The extension of the North Shore branch of the Long Island

Railroad presaged growing interest, a development that was reflected in New York City newspapers in the 1920s advertising "North Shore beach" land in Rocky Point for $89.50 per lot. At first, city residents who purchased the property used it as summer residences while year-round inhabitants were relatively few until the late 1940s and 1950s, when the population exploded and summer homes were converted to year-round abodes while builders cleared the land and constructed new homes. Italian Americans would soon form the largest nationality bloc locally.

SAINT ANTHONY OF PADUA

Growth in the region was so rapid that by 1948, a need was felt to plan for the large influx of its Catholic population, which had been served in a limited way by Saint John's Church in Wading River. Against this background, Brooklyn archbishop Thomas Molloy entrusted the task of creating the new parish of Saint Anthony of Padua to Father Vincent Margiotta, who was familiar with the area because he used to spend summer vacations in nearby Patchogue. Accompanied by Father Tortora of Our Lady of Mount Carmel in Patchogue, Father Margiotta made contact with Rocky Point laymen Joseph Bongiovanni and Anthony Spasaro and concluded that Rocky Point needed a church of its own with which to identify. Bongiovanni became chairman of a building fundraising committee that began to solicit donations every Saturday night from the patrons of six bars and grills in the community. Donations were very generous, enabling the committee to accumulate $3,700 and thus move closer to beginning the church construction. In the meantime, commencing on July 25, 1948, Mass was celebrated on Sunday in De Bari's Pavilion, which in summertime drew large crowds. Mass was also celebrated in the Bongiovanni and Spasaro homes, until finally, on Christmas Eve 1951, the first Mass was said in the new church building. In 1954, the burgeoning parish of Saint Anthony of Padua purchased ten acres from R.C.A. Corporation and proceeded to build a new church at a cost of $135,000. While the new church was under construction, Confraternity of Christian Doctrine classes were held in the P. Vincent Landi Sons of Italy Lodge.

A look at the names of assistant pastors and pastors of Saint Anthony of Padua underscores the ongoing Italian ambiance. From the 1950s to the 1990s, they included Reverends Maetta, Prinzo, Savastano, Della Rosa,

Monsignor Margiotta Parish Center, named after Monsignor Vincent Margiotta, founding pastor of Saint Anthony of Padua in East Northport. *Courtesy Salvatore LaLima.*

Derasmo, Gaeta, Cappuccino, Cassar, Maffeo, Belifiore and Catanzaro. Meanwhile, Monsignor Margiotta had been named pastor of Saint Rocco's Church in Glen Cove, while Father Mistretta was appointed pastor of Saint Anthony of Padua followed by Reverend Joseph C. Coschignano in 1989. During the latter's pastorate, Saint Anthony's completed the Monsignor Margiotta Parish Center. Of course, priests of non-Italian descent also were assigned to Saint Anthony, such as Father Richard P. Hoerning, the pastor in 2013.

Rocky Point's history is also intertwined with that of famed Italian wireless inventor, Guglielmo Marconi, whose historic 1902 wireless station had been moved to the R.C.A. Communications site in the hamlet. In 1969, the deteriorating old radio shack had been transferred to the Rocky Point School District, from which, with construction funds supplied by the P. Vincent Landi Sons of Italy Lodge, it underwent extensive repairs under the guidance of Rosario Aurucci and Frank J. Carasiti, Rocky Point's future superintendent of schools. The building is currently maintained by the Rocky Point Historical Society.

The Marconi sending station of 1902, restored and located at the Frank J. Carasiti School in Rocky Point.

MANORHAVEN

Bordered by the communities of Port Washington and Sands Point, the village of Manorhaven sprang up largely on acreage previously worked as sand quarries and consequently spurned by inhabitants of old Port Washington. To dispose of the low-lying land, the Canterbury Real Estate Company resorted to looking elsewhere to peddle it, especially, New York City residents, who responded eagerly to the blandishments of the real estate promoters who advertised plots in sand-evacuated areas for $100 a lot. First- and second-generation Italian Americans were the most prominent purchasers, thus giving an Italian ambiance to the area. Early village settlers included a combination of New York City residents who had built summer cottages there, as well as others who would be year-round residents. Italian-born Gregory D'Elia, who combined a real estate career with journalism, played an influential role in this development because he wrote a column for *Il Progresso Italo-Americano* promoting the virtues of the community into which he moved personally in 1950. He also began to write a column in the Italian language for a new community newspaper titled the *Post Reporter*, which provided information about the local Italian community. D'Elia's role emphasized the importance of Generoso Pope as a catalyst for growth, partially as a byproduct of Pope's sand and gravel business. Price was also an inducement since, in contrast to wealthier towns nearby, homes were less expensive. The tightly packed area, covering less than half a mile, became a domain of one- and two-family houses on forty- by one-hundred-foot lots, and rentals were plentiful. From a population numbering five hundred in 1937, Manorhaven grew to over ten thousand in the next three decades.

By 1930, when Manorhaven's residents engaged in a drive to incorporate to enable the village to have a greater influence in determining its future, Italian Americans had become active participants in civic affairs. The 1964 election for mayor, which saw "Tony" Pasquale Solamita run on the Fidelity Party line, is one example. Forty-five of the sixty couples listed as party members had identifiable Italian names, as did many of the most recent mayors, including John Dileo, Nicholas B. Capozzi and Giovanna Giunta.

In 1943, Manorhaven obtained its own Catholic church—Our Lady of Fatima—originally a mission church created through the efforts of the Ladies' Guild after the outbreak of World War II. Following a period of using temporary facilities in 1945, the construction began on its own church structure. Further development came in 1953, when the new pastor, Father Leonard Pavone, raised funds from annual parish-sponsored festivals

to transform a warehouse into a youth center. A small church building by comparison to Catholic churches in nearby communities, Our Lady of Fatima served as a place of worship for working-class Catholics and those of more substantial means. Popular singer and television entertainer Perry Como, who lived in nearby Sands Point, together with his wife and family, was a parishioner for years where he was said to sing with the choir on occasion. A passionate golfer, Como headlined an annual "celebrities" golf tournament on behalf of Port Washington's Saint Francis Hospital, even after he had moved to Florida. The esteem in which he was held was reflected in 2002 in a yearlong nostalgic exhibit in the Port Washington Library that featured memorabilia of his career and the home in which the Como family lived for twenty-five years set against a backdrop of Perry's soothing song style. In addition, a Sons of Italy Lodge was named after him

Chapter 8
THE BUSINESS OF FOOD

Italian Americans have impacted the lives of Long Islanders for over a century with business activity that ranged from small to midsized trades, such as grocery stores, shoemaker repair shops, auto service stations, barbershops, landscaping, small manufacturing and other enterprises. Joining the early pre–World War II waves of newcomers were immigrants of the last great wave of Italian immigrants who came to this country in the 1950s and 1960s, many of whom made their mark in the food and restaurant business.

FOOD

It is the theme of a 2011 publication that Italian food has conquered the world—perhaps to some an exaggerated concept. However, in poll after poll, it consistently appears at or near the top of preferred cuisines the world over, certainly true in the United States. Much of its popularity is attributed to the influence of Italian immigrants who introduced their cuisine and cooking methods and adapted their native foods to local ingredients. It would be an understatement to say that Italian Americans are well represented in the food industry, where they enjoy prominence in Italian specialty grocery stores, the restaurant business and pizza parlors. Simply put, they are ubiquitous in Nassau and Suffolk Counties, with multiple examples in most hamlets

and towns, leading to the conclusion that virtually no community can be found without at least one such an establishment. In this account, I can only provide a sampling profile in each category.

ITALIAN GROCERY STORES

Iavarone Brothers Foods

This unique chain of Long Island Italian grocery specialty stores began in Brooklyn in 1927, eight years after Pasquale Iavarone landed on Ellis Island. It began as a pork store that produced sausages that became so popular that police barricades were erected during holiday times to control the crowds clamoring for the product. Pasquale's sons, Joe and Jerry, joined their father in the business and while maintaining the original store, like other Italian Americans, they, too, moved to Long Island, where they subsequently opened more stores. At a meeting with Frank Perdue, the president of one of the largest chicken producing companies in the United States, they introduced a new healthy product: "chicken sausage."

In the 1970s, the third generation of Iavarone brothers, Pat and John, opened new stores where the family legacy continued with a new twist—the introduction of a rather new concept of "prepared foods" and hot catering to hungry customers on the run. They also began to distribute their own fresh pasta known as "Iavarone Bros. Villa di Pasta." This brand became the exclusive line of fresh pasta products sold in all their stores. They also searched out products in other countries, which they began to sell under their own label, and expanded their operations into full-scale gourmet markets. They have developed a growing niche market among those people who have moved away from Long Island but use the Internet to order Iavarone products. Currently, Christopher, Jonathan and Michele Iavarone, the fourth generation to enter the family business, operate four Iavarone stores.

A&S Fine Foods

Although not located exclusively on Long Island, A&S Fine Foods (formerly A&S Pork Stores) have a strong presence in Nassau and Suffolk Counties. The origins revert to 1937, when at age fourteen Anthony Scicchitano came

to America to join his family in Pennsylvania, where his father was working in the coal mines. Young Anthony himself worked for a short period in the mines but decided to move to Brooklyn, where he met and married Raffaele Fretta, whose father had opened one of Brooklyn's first Italian pork stores. Learning how to make sausage from his father-in-law in 1948, Anthony opened his own store and began to expand the merchandise to include cold cuts and other Italian food items. He continued to expand his operation, and by the time of his death in 2006, he had altogether twenty-eight franchised stores in Long Island and beyond that were transformed from A&S Pork Stores to A&S Fine Foods.

Uncle Giuseppe's Marketplace

Uncle Giuseppe's Marketplace is one of the newest and most popular Italian specialty grocery store chains on Long Island. The brainchild of Thomas Barresi and three Del Prete brothers—Philip, Carl and Joseph—the first Uncle Giuseppe's Marketplace store, which opened in 1998, reflected the founders' initial vision of joining the separate components of a typical urban Italian food shopping trip (the deli, the bakery, the pasta shop, the butcher and the fruit and vegetable stand) under one roof in a comfortable, family-friendly setting. The concept is proudly displayed in the Smithtown, Long Island thirty-three-thousand-square-foot store that is the flagship of five stores on Long Island. The Uncle Giuseppe's shopping experience offers the opportunity to satisfy the basic need for commodities in an atmosphere of product abundance, including certain nostalgic favorites that evoke recognition of long-gone ethnic city locales. The strong emphasis on fresh food and service has met with approval not only by Italian Americans of older generations but also among many of the younger generation. Moreover, it has drawn numerous shoppers of non-Italian descent who love Italian food and the ambiance offered in Uncle Giuseppe's Marketplace stores, replete with features such as fresh pasta, sausages and mozzarella made right in front of shoppers and Italian-inspired architectural and decorative details such as a hand-painted sky ceiling and scenes from Italy throughout the store. Shoppers can select fresh fruits and vegetables in the produce market section, turn to another isle for freshly made cannoli in the Italian bakery section and fresh swordfish in the capacious seafood departments. These markets feature a full-service deli; a pizzeria and hot-food section with abundant seating; a candy store with chocolate fountains; an espresso bar; a

Several branches of Uncle Giuseppe's stores on Long Island provide shopping for food in an atmosphere suffused with a lively Italian ambiance.

floral section; a fresh cheese department with hundreds of varieties from all over the world; and daily prepared sushi.

RESTAURANTS

Whether via anecdotal observation or from more objective published surveys, Italian restaurants reign as the most popular eating places on Long Island, a phenomenon due in part to the large base of the Italian ethnic cohort that resides in Nassau and Suffolk but also because of the cuisine's popularity among the general population. Pop artist and Long Islander Billy Joel captured the pervasiveness of Italian restaurants in his ballad "Scenes from an Italian Restaurant," composed in 1977 and said to have been inspired in Christiano's Restaurant in Syosset when a waiter serving him asked, "A bottle of white, a bottle of red/Perhaps a bottle of rosé instead?"—one of the ballad's most memorable lines. Although no official count of the number of Italian restaurants that make Long Island their home exists, there must be hundreds, ranging from small, family-run establishments that were founded in ethnic neighborhoods of an earlier era to opulent, stand-alone

operations in prestigious locations. Indeed, every Long Islander has his or her favorite Italian restaurant. In Massapequa, it likely would be the Zagat-rated excellent Il Classico, where master chef and owner Eddie Maiorini offers a tasteful dining experience that combines Old World taste and charm with New World sophistication while in Amityville, the choice likely would be Bellissimo Ristorante Italiano, owned and operated by the Guella family and whose menu reflects traditional Italian cuisine with both Tuscan and Sicilian influence. In Rockville Centre, Dodici gets the nod while Gemelli in Babylon is a favorite.

Stango's

A survey of a cross section of Italian restaurants offers an opportunity to measure their prominence. Stango's of Glen Cove, which lays claim to being the oldest ongoing Long Island Italian restaurant, had its beginnings in the heyday of Italian immigration of the early twentieth century. A family-operated restaurant begun in 1919 by Concetta and Frank Stango, who initially catered to Italian immigrants living in the Orchard neighborhood, it continued to be run by family members for ninety-four years. Ninety-six year-old Stella Stango Cocchiola, daughter of the founders, has remained a fixture in the establishment constantly greeting customers with a smile and friendly charm. Alas, by 2013, beset by years of a poor economy, the family concluded it would leave the business. After updating and alterations, Stango's restaurant will continue, however, under a new ownership group led by Thomas Suozzi, former Nassau County executive and mayor of the city, and his wife, Helene. The Suozzi family is no stranger to Stango's—Judge Joseph Suozzi, Thomas's father, used to work there as a bus boy during his youth.

Family-run businesses were typical of Italian restaurants. And once they gained favor beyond the ethnic community, they became mainstays for generations—a number evolving into chain restaurants with a presence beyond Long Island. One conspicuous instance was the Sbarro family, which emigrated from Naples to the United States and became famous and very prosperous in the field of Italian cooking. In 1956, Gennaro and Carmela Sbarro with their three sons—Joseph, Mario and Anthony—arrived in Brooklyn and soon opened their first salumeria (Italian grocery store) in Bensonhurst. Offering a fine array of exceptionally fresh food and genuine Italian fare, including homemade mozzarella, imported cheese and tasty sausage, it quickly became very popular and led to the opening of more

Found throughout the world, the Sbarro chain of Italian eateries can be found in numerous shopping malls such as this one in the Sunrise Mall in Massapequa.

stores in the New York City area. That early success led to the opening up of a restaurant in a shopping mall, an enterprise that was so successful that shortly afterward, Sbarro's restaurants would be found in numerous malls and food courts in other locations, where they offered authentic Italian food on a fast self-service basis. The decor of Sbarro units incorporated traditional Italian colors of green, white and orange of the Italian flag, along with replicas of cheeses, salamis and prosciutto hams hanging from the ceiling, reflecting the company's origin as a delicatessen. Sbarro's, which continued to expand nationally and internationally into dozens of countries, runs its global operation from the Sbarro headquarters in Melville, Long Island. When Gennaro Sbarro passed away in 1984, the Sbarro empire numbered ninety-seven stores and grossed $20 million of revenue annually. Sbarros would achieve the distinction of being the fifth-largest pizza chain in the country (after Pizza Hut, Domino's Pizza, Papa John's and Little Caesar's) and continued to grow as various members of the Sbarro family oversaw its phenomenal expansion. Meanwhile, Carmela "Mama" Sbarro persisted in working in the original Brooklyn store until she suffered a stroke in 2004, after which the Brooklyn location ceased to exist.

Financially, Sbarro decided to sell stock and go public, only to repurchase the company for $400 million, and finally, facing bankruptcy,

the business became the property of a private equity firm. Notwithstanding its gyrations, the Sbarro name endures under new management, which is making strides in working out its financial problems; it also has resumed expansion overseas.

Umberto

On a smaller but nevertheless successful scale is the saga of another family of Italian immigrants in that post–World War II period: the Corteo family of Umberto's of New Hyde Park. Umberto Corteo, one of thirteen children born in the outskirts of war-torn Naples, Italy, decided to immigrate to Brooklyn as a teenager in his struggle to earn a livelihood. He would soon be joined by other brothers, including Joe, who became a partner that opened the Original Umberto's in New Hyde Park, Nassau County, in 1965. Joe then brought the originality and authenticity of Umberto's to Florida, where he opened an Umberto restaurant while Carlo, the youngest brother, who worked after school at the Original Umberto's, assumed Joe's position on Long Island.

By the beginning of the twenty-first century, the Original Umberto's had become a Long Island landmark, even as it transmuted from its early

The popular Umberto's Restaurant of New Hyde Park.

Salvatore Corteo, flipping pizza dough at Umberto's. He is a family member of the Corteo clan that operates Umberto's Restaurant. *Courtesy Anthony Corteo.*

roots as a cozy pizzeria into an impressive complete two-story Italian restaurant, enhanced by Tuscan architectural design that proffers a full-service café and a four-star dining room. The Original Umberto's of New Hyde Park can boast of several distinctions, including selection in several surveys as providing the "Best Pizza" on Long Island and the restaurant that has supplied pizza for the New York Giants football team. There are also Umberto's pizzerias in Wantagh, Garden City and Lake Grove, all operated by family members, while other relatives have spread the Umberto's magic to Florida via three spinoffs.

The emergence of "grandma pizza" is another culinary phenomenon associated with Umberto's. According to one account, two of their pizza makers, Ciro Cesarano and Angelo Giangrande, saw the potential in selling the still unnamed thin-crusted pizza strewn sparingly with tomatoes from the garden and just a little cheese—as it was done in the Italian countryside. Thus, it happened in the mid-1980s that "grandma pizza" made its debut in an Umberto's restaurant and shortly thereafter was duplicated elsewhere.

Mama Lombardi

The Lombardi family of Holbrook, Suffolk County, has created a virtual culinary empire in the heart of Holbrook. This restaurant domain began in 1976 with the opening of Mama Lombardi's, a Neapolitan eatery in Holbrook, which nearly four decades later still serves up classic Neapolitan cuisine in an elegant setting. In local surveys, it has frequently been cited as the best Italian restaurant in the community. Lombardi's has expanded over the years to include a private wine cellar available for special occasions and

Located in Holbrook, Momma Lombardi's is considered one of Long Island's finest Italian restaurants.

is connected to Lombardi's Catering Hall, an upscale facility that has been servicing customers from eastern and central Suffolk for years. Currently, the family owns a market where it provides Italian gourmet food under its own label. Altogether, it operates four restaurants, of which the two-year-old Lombardi's on the Bay is the youngest and most elaborate and, interestingly, primarily a steakhouse.

Matteo's

In the mid-1980s, Salvatore Sorrentino and his two sons, Andrew and Matteo, started their restaurant chain Matteo's, first in Hewlett, Long Island, and then moved it to Bellmore, the standout place that soon became celebrated for good Italian food and generous portions. It was still another account of an Italian family-run eatery in which the original owners, children and extended family members contributed to success and expansion. By the time the chain of stores was sold twenty-five years later, it boasted of nine restaurants, five on Long Island and four in Florida.

Catering Halls

Supported by both comprehensive surveys and anecdotal evidence, the role of formal catering halls is much more substantial in society in the New York metropolitan area than elsewhere on the East Coast. According to a 2012 survey that covered eighteen thousand people, Virginians spend 25 percent less than New Yorkers for wedding receptions, for example. The numerous catering halls that have evolved from restaurants and the stand-alone enterprises that depend primarily on bookings for christenings, sweet sixteen parties, bar mitzvahs, organizational testimonial dinners, etc., are an unmistakable feature of life on Long Island. The 2012 survey showed that Long Island had the most formal weddings, with 37 percent as black-tie events costing an average price tag of $50,000—clearly the most expensive service they render.

Among the many caterings halls run by Italian Americans is Giorgio's of Baiting Hollow, Suffolk County, which is owned by George Regini Sr., who founded the establishment in 1994. Regini Sr. brought into his enterprise a vast experience covering over forty-five years, during which time he orchestrated elegant banquets at such prestigious places as the Waldorf-Astoria and the Pierre Hotel. His son George Jr. worked at his father's side as a youngster and currently runs every banquet at the facility.

Members of the Sacco family have been in the catering business for fifty years and operate Verdi's of Whitestone, Queens, as well as Verdi's in Westbury. Consistent with the notion of a family-run business, one of the Sacco brothers serves as the executive chef in the Westbury location.

Perhaps the Italian Americans who have made the most indelible impact in the catering hall business, though, are the members of the Scotto family, who have provided a model for immigrant success in the United States. Leaving their home in the vicinity of Naples in 1961, three Scotto brothers—Anthony, Vincent and Victor—with their large and close-knit families became part of the last great wave of Italian immigration. Upon arrival, they worked for their uncle's Italian restaurant in Brooklyn, New York, and after six years of hard work and dedication, in 1967, the brothers and their brother-in-law opened their first restaurant, Scotto's Pizzeria and Restaurant in Port Washington, with a second location in Great Neck. They followed this with opening steakhouses but ultimately emerged as preeminent leaders in Long Island's hospitality business. The Scotto brothers established their first banquet and catering facility in 1978 in Carle Place, Nassau County, an establishment that is decorated in the golden age art deco style, which they

dubbed "Chateau Briand." In 2002, the Scotto brothers opened the inn at Fox Hollow on an eight-acre site in Woodbury that features a luxury hotel next to the catering hall. From 1982 to 2004, the brothers also operated the Westbury Manor, a prestigious former mansion with six enchanting gardens and Victorian charm. However, in 2004, the Westbury Manor was spun off; its sole owner and operator was Jerry Scotto, Anthony's nephew. The Watermill Inn in Smithtown, New York, was another major reception hall operated by the Scotto family

At its peak in 2001, Scotto Brothers Enterprises catered some 3,500 weddings a year in its four catering halls on Long Island and more than a dozen steakhouses. It served eighty thousand meals weekly, reported sales of $100 million and employed two thousand workers, full and part time, including more than a dozen Scotto family members. It also operated three restaurants in Las Vegas.

THE BUILDERS

A good case may be made that Italian Americans have been crucial to Long Island's construction industry for well over a century, whether as ordinary laborers of the late nineteenth and early twentieth centuries or as owners of small construction firms that built single-family homes. For example, they were the main workforce in the construction of roads like Jericho Turnpike in Roslyn, Route 112 in Patchogue, the reservoir for the New York Water Company in Nassau County and the Vanderbilt Motor Raceway. They also became owners of numerous construction companies throughout the island that continue to build and remodel residential homes. In countless instances, although not professional construction workers, upon moving to the suburbs, Italian Americans proceeded to build their own bungalows. Not surprisingly, a number of Italian Americans rose to the top of the construction industry, some of whom will be discussed here.

SCALAMANDRE

Freeport's Scalamandre family, which operates one of the island's largest and most successful construction enterprises, traces its origin to Calabria, Italy, where Peter Scalamandre was born. Resuming civilian life after serving in the Italian army, he married Bettina Pagnota and came to America, settling in Freeport, where a small enclave of Calabrians lived.

Like many of his compatriots, he began working in the construction field, becoming so proficient in masonry that he started his own business in 1929—a small enterprise that focused on driveways, brick steps, sidewalks and foundations. In that period, masons worked their labor-intensive trade as they had for centuries, but once new concrete-mixing methods were developed, Scalamandre was quick to relinquish the obsolete process, adopt new technologies and expand the company's horizons. By the 1980s, his two sons, Fred and Joseph, had joined in the enterprise as it developed its expertise in concrete that won it contracts for town curb construction projects, a shopping center and other public facilities.

Into the twenty-first century, the Scalamandre construction operation includes eight subsidiaries that collectively build bridges, sewers and drainage systems. Now run by the third Scalamandre generation, it remains one of the island's leading heavy equipment construction firms. Like its predecessors, the current generation continues its involvement in civic, religious and community activities. For example, Peter—president of Peter Scalamandre & Sons, Inc., who graduated from Utica College with a degree in construction management—is a member and past president of the Concrete Contractors of New York. Devoted to helping others in need, Peter sits on the board of the De La Salle School for underprivileged middle school boys in Freeport.

POSILLICO

The Posillico name has a long history in Farmingdale, dating to the early part of the twentieth century, when Joseph Posillico served as deputy sheriff of the community's Italian enclave. In 1946, Joseph D. Posillico, a descendant, who was a small trucking contractor, founded the Posillico Construction Company that supplied bricks for the many new homes being built in post–World War II suburbia. The firm continued to expand as other members of the family assumed responsibilities, including Mario A. Posillico, who promoted the firm's role in public works projects, while Joseph D. Posillico Jr. led the company into the asphalt business, as well as in the installation of deep drainage and sewer systems resulting in the completion of over $500 million in sewer infrastructure. By the 1980s, J.D. Posillico, Inc., had emerged as a major road construction company with work contracts to improve and rehabilitate the Northern State and Southern State Parkways. It also

formed a unit that focused on environmental services, including industrial remediation, transportation and disposal of contaminated soils, process treatment systems and underground petroleum tank removal and disposal. By the early years of the twenty-first century, under the third generation of Posillico family members, the firm name had changed to the Posillico Civil Inc., with separate company names for its asphalt, environment, engineering and consulting units. It normally employs several hundred workers and regularly wins hundreds of millions of dollars in contracts.

Castagna Construction Corp

One of the oldest continuously operated Italian American construction firms that persists as a major player on Long Island is the Castagna Construction Corp. founded in 1922 by Ferdinand Castagna as Gerace and Castagna Inc., a masonry-contracting company. It operated as a general contractor, performing masonry and carpentry with its own construction crews while subcontracting the balance of the general construction to other specialty contractors. By the mid-twentieth century, Castagna Construction had become the premier hospital builder in New York City; it had developed an expertise in the intricate knowledge of constructing relatively complicated structures that it soon extended to construction of prisons, courthouses and nursing homes. In 1950, Ferdinand's son Frank Castagna, who studied civil engineering, joined his father to form Castagna & Son Inc., which functioned as a general contractor and construction manager. Frank would make his own impact in the family firm for well over fifty years. Thus, in 1955, the company purchased property in Manhasset and began development of Americana Manhasset (originally called the Fifth Avenue of Long Island), a premier upscale shopping center that includes a collection of international shops that rivals those on Madison Avenue or Rodeo Drive. Accordingly, Castagna & Son relocated its headquarters in the Americana flagship setting and proceeded to construct such Long Island projects as North Shore Hospital in Manhasset, Nassau Veterans' Memorial Coliseum, University Hospital at Stony Brook and the Wheatley Plaza in Greenvale, which in 1982 received the Annual Shopping Center Award for innovative design and construction. In addition, it has constructed projects elsewhere such as the New York City Police Headquarters, New York State Supreme Courthouse, Albert Einstein College of Medicine and New Bellevue

Hospital, as well as residential developments in upstate New York. At one time, the privately held firm had more than one thousand employees. It currently operates under the Castagna Realty Company Inc. aegis.

Frank Castagna has also demonstrated a strong interest in civic and philanthropic activities, serving, among other things, as chairman of the board of the Tilles Center, the premier arts showcase of the island. He serves on the board of the Nassau County Museum of Art and the National Disabilities Services in Albertson. He is on the board at Old Westbury Gardens, the Institute for Community Development and the Anti-Defamation League. He works closely with North Shore University Hospital, Schneider's Children's Hospital, Long Island Jewish Hospital, the Long Island Juvenile Diabetes Foundation, the North Shore Child and Guidance Association, Saint Francis Hospital, the Arthritis Foundation and Mommas, a home for unwed mothers.

RACANELLI

The Racanelli Construction firm that was begun by Nicholas Racanelli in the mid-twentieth century continues to play a key role in the construction of Long Island's commercial and industrial building and land development. Nicholas, a careful student of potential community development opportunities, took the time to identify business sites that were in proximity to major thoroughfares, rails and airports as favorable sites in which to build high-quality office and industrial structures. In time, he was joined by his sons, and by the 1980s, they had developed 1,250 acres of commercial and industrial property sites, which included over three hundred buildings comprising 13 million square feet of space. Under the name Racanelli Construction Company Inc., Nicholas, Michael and Marty Racanelli, of the family's third generation, run the firm in much the same way as their ancestors did—with vision and commitment to high-quality construction and customer service.

Among the large projects Racanelli supervised were the remodeling of the synagogue in the Sands Point section of Port Washington and the renovation and reconstruction of an existing factory building (former Bulova Watchcase Factory) in Sag Harbor into luxury condominiums with many amenities. The Racanelli family also has demonstrated an interest in supporting civic and philanthropic causes as evidenced by the honor tendered by the

American Heart Association to Nicholas H. Racanelli in 2009 during a New York Yankees game. The Racanelli organization has been actively involved with the American Heart Association for over two decades

ALBANESE

The prestigious real estate development firm, Albanese Organization of Garden City, one of the island's most respected companies, is traced to Anthony Albanese, the son of Italian immigrants who grew up in South Ozone Park, Queens, and who at age nineteen borrowed $1,000 to enable him and his brother Vincent to enter the real estate industry. Joined by Joseph, another brother, in 1958, the firm, now called Albanese and Albanese began very modestly constructing single-family homes and apartment houses. As business grew in the 1970s, it opened its headquarters in Garden City, where it undertook projects that expanded the scope and breadth of the operation, constructing office buildings locally. Simultaneously, it entered the Manhattan real estate market by acquiring underutilized commercial and residential properties on the eastside and developed the fifty-two-story pyramid-topped condominium known as 100 United Nations Plaza.

By 2000, Anthony's son Russell and nephew Christopher had joined the firm, helping it to become the developer of the first high-rise residential building in the country to be built in accordance with the United States Green Building Council's Environmental Design guidelines—the Solaire, the first structure to be constructed near the site of the World Trade Center building after September 11, 2001. The Solaire was the first of three internationally recognized sustainable buildings that the Albanese Organization completed in Battery Park City. In 2011, the firm was designated by the Town of Babylon as master developer of a major community revitalization project in Wyandanch.

Anthony Albanese contributed to the betterment of the community by serving as a village trustee in Plandome and as a member of the board of trustees of Saint Francis Hospital in Roslyn. His son Russell follows in his father's footsteps with regard to meticulous attention to the quality of the firm's work and charitable activities. In 2012, he was honored for his leadership role by the Long Island Chapter of the U.S. Green Building Council.

Other Italian Americans who have made a mark in Long Island's construction and real estate industries include the DeMatteis organization, Charles Mancini, Sal Ferro and Don Monti. The DeMatteis Organization, which began operations over ninety-five years ago, will be discussed more extensively later. Mancini, president of Park Ridge Organization, served as president of the New York State Builders Association in 1989 and remains a board member today. He is currently a board member of the Long Island Builders Institute, after serving the organization in a variety of roles, including president and chairman. In 2004, he was inducted into the New York State Builders Association Hall of Fame. In 1988, Sal Ferro joined Alure Home Improvements, which originated as a paint company but which he helped transform into one of the nation's most outstanding remodeling companies. He became company president in 2001 and brought it television fame via the popular program *Extreme Makeover*. Under his guidance, the Alure Company received the Forbes Enterprise Award for visionary practices and achievements in 2007. Don Monti is president and CEO of Renaissance Downtowns, a real estate development company based in Plainview that has undertaken ambitious projects aimed at reviving aging downtowns such as a $2 billion endeavor in Hempstead. Monti's firm is also a major player in a proposed project to redevelop the Nassau Veterans' Memorial Coliseum.

SUCCEEDING IN BUSINESS IN THE ITALIAN FAMILY TRADITION

GUITAR MAKING

Certain fields of endeavor pursued by Long Island Italian Americans recall centuries of Italian tradition carried over from Europe to the New World. One of them, guitar making, would be found in the work of legendary craftsmen who came to America to pluck their instruments, particularly the D'Addario clan. Settling first in Queens, New York, Rocco and Carmine (Charles) D'Addario pursued the family tradition of making guitar strings, a process that involved the entire family. With the growth of popular music in the 1920s and 1930s, their business expanded in response to orders from individual musicians and guitar manufacturers. In the 1950s, John D'Addario, Carmine's son, settled on Long Island, where he pursued the trade manufacturing market strings under his own name, first in Lynbrook and then in larger facilities in Farmingdale where thirteen family members worked. Jim D'Addario, the ninth generation of the family in the business, created the first custom-designed automatic string-winding machine, which has turned the art of string-making into a science. The flourishing company also has a plant in California and altogether employs some nine hundred people.

FIREWORKS

To Long Islanders, the mention of pyrotechnics readily conjures up the name of the Grucci family. And for good reason—the family has been in the business since 1850, when Angelo Lanzetta, who began to develop his pyrotechnics artistry into an industry, came to settle in Elmont, Long Island. Felix Grucci, Lanzetta's nephew, and Felix's wife, Concetta, both of whom learned the trade from Lanzetta, opened a pyrotechnics factory in Bellport, Long Island, in the 1920s, while raising a family of three children who also entered the business. Over three decades, Felix Grucci Sr. earned a reputation as a master fireworks manufacturer, adding to his fame when he developed the stringless shell, considered a landmark innovation that advanced firework safety since it eliminated burning fallout. He had earned such a reputation in the field that the Department of Defense contracted with his firm to produce an atomic device simulator for troop training. Notwithstanding the general decline in the fireworks industry in midcentury, the Grucci enterprise survived and even flourished, supplying pyrotechnic displays not only locally but also nationally—their spectacular displays for the nation's bicentennial celebration with fireworks on the Charles River accompanied by Arthur Fielder's Boston Pops Orchestra merited rave reviews. International fame followed. In 1979, the Gruccis became the first American family to win the gold medal for the United States at the annual Monte Carlo International Fireworks Competition; they became known as "America's First Family of Fireworks." In 2008, they produced the greatest fireworks display in the world in Dubai, with over 250 pyrotechnic technicians working on site for two weeks.

The success of the business did not, however, spare the family from tragedy. In November 1983, the family's factory inexplicably exploded, killing James Grucci, son of the founder, and a cousin, while also injuring twenty-three workers. The devastation prompted Felix Grucci Jr. to say, "We went from a very high because that same year we produced the Brooklyn Bridge Centennial to the very lowest. We lost all of our inventory, our entire facility was leveled and we lost two very dear members of our family, one of which was my father." Relocating from Bellport to Brookhaven, the family soldiered on, rebuilding the business through technology and innovation, to emerge as an industry leader once again. The Grucci fame enabled Felix Grucci Jr. to achieve some success politically, including election to the Brookhaven Town Council, a four-year term as town supervisor of Brookhaven and election to

the United States Congress in 2000, where he served one term. In 2013, a fifth generation of the family has been named to head the firm now called Fireworks by Grucci.

WINEMAKING

Winemaking is another industry associated with Italians, one that has a major presence in California in the spectacular successes of Gallo, Mondavi, Sebastiani and Martini, among others, that dot winery signs and stand as a constant reminder of the contribution of Italian Americans in the growth of America's now internationally renowned wine industry. Long Island's winemaking, along the North Fork of Suffolk County, is of later development—taking place on land that was essentially potato fields until the 1970s. Since then, Long Island winemakers have steadily emerged to become producers of some of the best reds and whites east of the Rocky Mountains. New York's wine industry was aided by strong support from New York State as Albany enacted laws to facilitate and encourage vintners, such as reformulating the winery license so grape growers could operate wineries. The state's winegrowers were especially pleased with the administration of Mario Cuomo, three-time governor of the state, who, together with his wife, Matilda, energetically promoted New York–produced wines. Cuomo initiated legislation permitting the sale of wine coolers in grocery stores as well as liquor stores, which gave a major boost to New York's grape farmers. Under Cuomo's aegis, the New York State legislature also enacted a "winery deregulation" law that helped small-farm wineries better market their product. In addition, Cuomo included funds in his budget long sought by Long Island's wine industry to promote research for the state's wineries and insisted that New York wines be used for events at the executive mansion and family events, such as weddings. For her part, Matilda Cuomo promoted the cause in her travels—for example, asking an airline why it did not serve New York State wine. By the end of the century, New York was the third-largest grape producer in the United States after California and Washington.

Compared to the rest of the state. Long Island is a young wine region; however, the industry has grown quickly to over three thousand acres and thirty-eight wineries that have garnered numerous awards and increasing attention at prestigious wine events. They produce wine from primarily *Vitis*

vinifera grapes that have become competitive with long-standing European wine producers. Italian Americans have made an important contribution in this enterprise operating vineyards varying in size from small to large—some of which will be discussed here.

Pellegrini

Although Cutchogues's Pellegrini Family Vineyard opened for business in 1991, the Pellegrini family has been planting high-quality chardonnay and merlot grapes on thirty acres for more than twenty-eight years. In 1982, Bob Pellegrini, a graphic designer, and his wife, Joyce, a retired schoolteacher, determined to produce the best wine possible, expanded their operation after purchasing three more nearby parcels for a total of ninety-eight acres. They painstakingly designed and constructed a state-of-the-art facility employing the latest winemaking technology along with an aesthetic sensibility. The result is an award-winning variety of wines and a picturesque building that attracts droves of photographers and the occasional film creators.

Macari

Since 1959, Queens resident Joseph Macari Sr. has owned a total of 500 acres on the North Fork, including 180 acres planted with grapes at Sound and Bergen Avenues. In 1995, he and his son Joseph Jr. of Cutchogue acquired the 39.5 acres of the former Mattituck Hills Winery from a local bank that had previously foreclosed on the former owner. Farther expanding their holdings in 2007, Macari Winery purchased the 41-acre Galluccio Winery, once considered one of New York's most promising wineries that had originally been bought for $55.5 million. Purchase of the Galluccio property gave Macari a tasting room on Route 25, the main thoroughfare, where customers can come sit and taste their products. The newly acquired property also included a large section of superior grape plantings. The Macaris have developed what has come to be regarded as an ambitious winery that garnered numerous accolades for its wines, producing eight thousand cases annually. An indication of how highly its product is regarded is evident in the fact that, at one point, the Clinton White House ordered five cases of Macari Vineyards '97 Barrel Fermented Chardonnay, the winery's second vintage. Macari, who is an organic farming pioneer with

a commitment to biodynamic farming methods, even maintains a herd of longhorn cattle to provide manure.

Sannino

Anthony and Lisa Sannino, owners of Sannino Bella Vita Vineyard in Cutchogue, started their business in 2006 after Anthony, a building contractor, built their home, which also serves as a bed-and-breakfast, in Cutchogue. Harkening to his grandparents who made wine in Italy before immigrating to Brooklyn, Anthony, largely self-taught, purchased a small vineyard and began to grow grapes that were prepared for release in 2009. The result was the production of five Bella Vita wines that met with lavish approval from critics.

Borghese

In 1999, Prince Marco Borghese and Princess Ann Marie Borghese entered Long Island's winemaking scene by purchasing Hargrave Winery, the oldest wine producers on the North Fork, which began operations in 1973. Respecters of tradition, the Borgheses capitalized on the historic noble family appellation by promptly renaming their winery Castello di Borghese and applied imagination and energy to render their vineyard one of the most admired in the North Fork. Expanding the operation, they greet visitors to their "castello," frequently joining in, or even leading, the many wine tastings held in their updated tasting room. Bottling their wines under their own labels, they have won numerous international awards. In recent years, North Fork wineries have become available for wedding receptions, with Castello di Borghese providing an Old World Italian flair with a taste of a rustic country setting; it is considered one of the most delightful locations for such an event.

Banfi

Banfi, the only winery in Nassau County, is also the largest of all Long Island's wineries. The winery, which is run by the Mariani family, was founded in New York City in 1919 and became the United States's leading importer

of wines, as it also operates vineyards in Italy that produce premium wines. Harry Mariani and John Mariani Jr. from Garden City are the proprietors of Banfi Vintners of Old Brookfield, Long Island, that employs 60 people locally and 140 worldwide. To prepare to run the Long Island operation, John Mariani attended and graduated from Cornell University in 1954, followed by two years of studying viniculture in the finest wine-producing sections of Italy, Germany and France. He became president of the Banfi Company, retaining the position until his brother Harry, who graduated from Colgate University in 1959 and who acquired extensive knowledge of the wine industry, including marketing, sales, finance and administration, succeeded him as president in 1964.

In 1979, the Banfi brothers purchased a sixty-room Elizabethan manse in Old Brookville, which was originally built for an English nobleman and converted into the Banfi Company world headquarters. Tastefully adorned in the European fashion with period furnishings and works of art, the redefined mansion sits on a lovely 127-acre estate and is a magnet not only for wine lovers but also for those seeking an extraordinary venue for social functions. Known for excellent wines under its own Villa Banfi label, in 1988, the Mariani family purchased a rival firm that enabled Banfi to connect with the leading wine exporter from Chile, thereby making it possible to serve a growing market for Chilean wine in this country—a trend that has seen sales grow from ninety thousand cases in 1988 to more than 2 million in less than ten years.

Introducing eco-balanced farming and low-input cultivation practices are among the many accomplishments of the Mariani brothers. Their Castello Banfi vineyards in Italy gained recognition as the first winery in the world to receive international recognition for exceptional environmental, ethical and social responsibility and for international leadership in customer satisfaction. The Banfi brothers have established the Banfi Vintners Foundation as its philanthropic arm, which has contributed to higher education, including endowed chairs at Cornell and Colgate Universities. It has also provided seed money to Catholic Relief Services to build a school, an orphanage and a housing project in Potenza, Italy, which was devastated by earthquake in 1980. In recent years, a third generation of Marianis have begun to operate Banfi Vineyards with Cristina, one of John's two daughters, and James, one of Harry's four children, serving as co–chief executives.

Successful Retail Businesses

Genovese

The Genovese Drug Store chain was for many years one of Long Island's most prosperous businesses. It was started in 1924 by twenty-one-year-old Joseph Genovese, a recent graduate from Columbia University's School of Pharmacy, when he opened a drugstore in Astoria, Queens. By the time of his death in 1978, the Genovese chain had grown to have fifty locations. The founder's eldest son, Joseph Jr., followed in his father's footsteps and entered the business after graduating from Fordham College of Pharmacy and began to expand the company. He introduced self-service to the chain and began buying out small drugstores and opening new locations. Over the next twenty years, under his leadership, the company grew dramatically and went public on the stock exchange.

Until 1996, the Genovese family continued to operate and grow the chain from its headquarters in Melville. One of only two family-controlled drugstore chains, it had 141 stores and five thousand employees in 1998 when it sold the company for $429 million in stock to Eckerd Corporation, the nation's third-largest drugstore chain and a subsidiary of JC Penny. The decision was prompted by the realization that economy of operation favored larger drugstore chains. Leonard Genovese, the chairman and chief executive of Genovese and the youngest son of the founder, explained that the transaction was in the best interest of customers, employees and shareholders. Over the next several years, former Genovese stores were rebranded into Eckerd's stores and then into Rite Aid Stores.

Castro Convertibles

The Castro story is another outstanding example of immigrant success in the land of opportunity, one that transformed a family from obscurity to world fame. It began in Sicily in 1904, when Bernard Castro was born, but like many of his countrymen, he immigrated to the United States in 1919 without knowing a word of English. Demonstrating a remarkable industriousness, he began to learn English while becoming a furniture apprentice. Bernard attended the New York Evening School of Industrial Art and received a degree in Interior Decoration in May 1928. Two years later, Bernard Castro and his wife accumulated $400 and went into business

for themselves, opening a small store called Castro Decorators. Operating his own business gave him the opportunity to utilize his ingenuity to experiment with furniture designs that would meet people's needs in space-cramped apartments during the Great Depression. The result would be the invention of the "Castro Convertible"—a step that would revolutionize the furniture industry. Television advertisements showing his four-year-old daughter, Bernadette, effortlessly opening the convertible couch with the accompanying tagline, "So easy to open, even a child can do it," became instantly etched in people's minds. It became the company's living trademark and the most televised commercial in the country, rendering not only instant recognition to the firm that precipitated a huge business expansion but also making Bernadette's name famous.

During the twentieth century, the Castro name would become synonymous with convertible couches and ottomans. At its peak, the Castros' furniture-making plant, which was based in New Hyde Park, Long Island, employed up to six hundred workers. Castro's success led to his winning the coveted Horatio Alger Award in 1963, in recognition of the belief that hard work, honesty and determination can conquer all obstacles. At his death in 1991, he had become a multimillionaire as a result of selling sold over five million convertible sofas through forty-eight retail showrooms in twelve states. Bernard Castro and his wife had two children—a son who died tragically at age twenty-six, and Bernadette Castro, who became a famous Long Island Italian American in her own right.

Bernadette Castro graduated from the University of Florida with a bachelor of arts, and she also attained a master's degree in educational administration at that institution. She became the first woman to ever receive the University's Distinguished Alumnus Award in 1985 while working in the advertising and promotions department of Castro Convertibles. While raising four young children, her activity in the business was limited; however, that changed after they were grown, and gradually she moved into her role as the company CEO. After the business was sold in 1993, Bernadette entered politics and ran a losing race for the United States Senate New York seat, though she did win an impressive 42 percent of the votes against highly regarded Senator Daniel Patrick Moynihan. In 1995, Governor George Pataki appointed her commissioner of the New York Office of Parks, Recreation and Historic Preservation. Under her leadership, her office preserved over one million acres of land during her twelve-year tenure. In recent years, she has returned to the family business, including overseeing a vast portfolio of real estate properties acquired by her father in several

states. Bernadette and her children have bought back the iconic Castro name promoting the Castro Convertible Ottoman, a product sold online and in many Macy's stores

Langone

A third-generation Italian American, Kenneth Langone was born in Roslyn Heights, Long Island, in 1935 during the Great Depression. He came from working-class parents who were the children of immigrants (his father was a plumber and his mother a cafeteria worker) he also had a brother and a sister. Because his parents came from large families, Ken grew up interacting with numerous relatives. Rejecting a principal's suggestion not to spend needed money for his college education, his parents mortgaged their house to send Kenneth to Bucknell College, and he worked as a butcher's assistant part time to help defray college costs. Ken had been accustomed to earning money since age twelve, when he sold Christmas wreaths door-to-door in season and cut lawns in the summer. He graduated from Bucknell in three and a half years and then proceeded to obtain his master's degree at New York University while working full time. He also served two years in the army. An inclination toward sales and promotion characterized his early business years, including three years as a "brilliant financial analyst" for the Equitable Life Insurance Company. Langone then set his sights on becoming a venture capitalist—a fund manager and professional investor in promising new businesses—an anomaly for a non–Ivy Leaguer Italian American and a Catholic. As a venture capitalist, he started a small investment bank that specialized in small start-up companies, making his initial mark by underwriting the stock of Ross Perot's Electronic Data System Inc.

Langone is perhaps best known as a co-founder of Home Depot, which he established in 1978 with two others who were interested in starting a home improvement operation. Langone provided venture capital for the company through Invemed, his investment bank, and, until 2008, served on the board as a member of the executive committee of Home Depot. Beginning with one store, Home Depot now has hundreds, employs over 300,000 people and grosses $70 billion annually as it has reshaped the home improvement industry.

In 2004, Langone attracted publicity first with his attempted purchase of the New York Stock Exchange but, most particularly, when he sparred with New York State attorney general Eliot Spitzer over the controversial

salary to be paid to Richard Grasso, the stock exchange president. Langone survived that fracas and also rose in the esteem of the Italian American community to be selected by the Columbus Club to serve as grand marshal of the 2009 Columbus Day Parade in New York City. In selecting Langone, Lawrence Auriana, chairman of the Columbus Club Foundation, stated: "Ken Langone is a virtuous man of good character, who is an ideal role model for Italian Americans and indeed all Americans."

Estimated to have a fortune of $1.3 billion, Ken Langone has used much of his money for worthy causes. As a philanthropist, Langone and his wife have donated close to $250 million to his favorite charities—the largest amounts to Bucknell University and New York University. Langone served fifteen years as a Bucknell University trustee and helped the institution to build the Kenneth G. Langone Athletics and Recreation Center in 2003. The donations made by the Langones to New York University have funded professorships, curriculum changes and student services to the Kenneth G. Langone Medical Center. At Home Depot, he funded Ken's Krew, a program that trains young adults with special needs to take on valuable roles in the workplace through employment with Home Depot and other corporate partners. Langone and his wife, Elaine, have three children and have been married for more than fifty years. They live in the village of Sands Point on Long Island and also have a home in Palm Beach. In recognition of Langone's support for Catholic causes, Pope Benedict XVI has named Kenneth Langone a Knight of St. Gregory.

Pascucci

Michael Pascucci is one of Long Island's most successful Italian American businessmen. But he was not born with a silver spoon in his mouth; indeed, his Naples-born Italian father, Ralph, was a member of the proletariat who worked as a landscape contractor. Notwithstanding only three years of formal schooling, Ralph improved his economic position by becoming a successful contractor, building roads and shopping centers as well as landscaping the newly created Levittown. The Pascuccis lived in Manhasset, where Michael went to high school and played on the school's football team, which featured Jim Brown, future Hall of Famer. Michael attended Bucknell University, where he studied finance, and working with his father as a contractor paid for his graduate work at New York University. Like his father, he demonstrated similar inclination toward entrepreneurship, and with a loan from his father,

he began his first venture in the automobile-leasing business. Sensing that the younger generation was ripe for car leasing, in 1974, he started Oxford Resources Corp., an auto-leasing firm that became a giant in its field. The Pascuccis purportedly earned $265 million after Barnett Banks Inc. bought the publicly traded company for $570 million in 1997.

Pascucci's most significant Long Island business venture was in the field of television. As a result of the experience he gleaned advising the Rockville Centre Catholic Diocese to develop a cable television operation, he realized that three million Long Islanders were without a television station of their own and that this hole in service offered an opportunity to start his own new commercial television station, which he did in Melville in 1995—WLNY, Channel 55. Although not an originator of programs, WLYN offered family-friendly entertainment consistent with the philosophy of Pascucci, a devout Roman Catholic. WLNY was making such considerable profit, primarily from reruns and movies, that it attracted the Columbia Broadcasting System, which purchased the facility in December 2011 for an amount rumored to be $55 million.

A senior citizen, Michael Pascucci continued his entrepreneurial activity with a $45 million cash purchase for three hundred acres of pristine land in Southampton in 2001 that he was determined to turn into a premier golf course. It helped that Michael enjoyed the sport and also that his next-door neighbor in Florida is legendary golfer Jack Nicklaus. Pascucci's Sebonack Golf Course is an exclusive club to which membership is offered to a maximum of two hundred people with a hefty membership fee. Thus, Michael is able to combine a sound real estate investment with an opportunity to indulge in his favorite pastime. Despite this expensive indulgence, Pascucci and his family are modest about their wealth and have established the Pascucci Family Foundation, which has given millions of dollars to a variety of causes. In addition, family members serve as trustees for various charitable groups.

COMING OF AGE

Education, Medicine, Law, Labor

Two to three generations removed from the pioneer Italian immigrants who established lasting enclaves in several Long Italian locations, the region's Italian American cohort has come of age. Italian surnames are familiar throughout all of Nassau and Suffolk. Members of the ethnic group whose proletarian parents and grandparents generally functioned on the periphery of society in an earlier era now are not only prominent but also indispensable in Long Island's economic, cultural and social life. They flourish as major, midlevel and small businesspeople in the business world, as we have seen, and beyond in the professions. Accordingly, although not designed to be comprehensive, several illustrations are in order.

EDUCATION

Whereas a couple of generations ago, relatively few Italian Americans could be found in Long Island's teaching ranks, they now are represented on a more equitable level. Italian Americans have also emerged as administrators in the fields of public and private education as principals and superintendents. Some examples include Frank J. Carasiti, James Brucia and Mary DeRose. Carasita, who began his teaching career in the Rocky Point School District in 1957, became acting superintendent of the district in 1963 and then permanent school chief until his retirement in 1990. Rocky Point School

Top: Sean Fanelli, first Italian American president of Nassau Community College. *Courtesy Sean Fanelli.*

Bottom: Dr. Salvatore J. La Lima, first Italian American president of Suffolk Community College, who remains active in community and ethnic affairs. *Courtesy Salvatore LaLima.*

District named an elementary school after him. Brucia became superintendent of the Massapequa School District in 1988 and served in that position until 1998. Mary DeRose joined the Kings Park School District in 1979, where in 1991 she was named superintendent of schools. Under her direction, the district introduced innovations that improved class transitioning and allowed for more class time for students. Upon her retirement in 2007, the Kings Park School District created the Mary DeRose Parent Resource Center, a comprehensive facility designed to help inform and empower parents about the social and educational issues that affect their lives. In 2013, DeRose, interim principal of Amityville High School, was awarded the Administrator of the Year honor.

That Italian Americans have made an indelible impact on Long Island's higher education was evident when three of them served as college presidents simultaneously: Frank Cipriani at Farmingdale State College, Sean Fanelli at Nassau Community College and Salvatore La Lima at Suffolk Community College. Cipriani, who has degrees from Queens College and speaks Italian fluently, began his lengthy career at SUNY Farmingdale as an assistant dean in 1964 and rose through the ranks into other administrative positions, becoming president in 1978. He maintained that post until his retirement in 1998. Brooklyn-born Sean Fanelli became president of Nassau Community College in 1981 and enjoyed one of the longest tenures in that position within the state system. He developed a reputation as a strong advocate of the college's academic mission and as a problem solver with open channels to faculty, union leaders and the county lawmakers who approve the college budget. He was an enthusiastic backer of the college's Center for Italian American Studies and an active participant in its Italian Heritage Day programs. In 2012, Hofstra University appointed Fanelli the new interim dean of its School of Education. Also born in Brooklyn, Lima came to Long Island in 1953 after serving in the U.S. Air Force during the Korean War. While working for Republic Aviation, he simultaneously attended Hofstra as a full-time student, earning his bachelor's and master's degrees. In addition, Dowling College awarded him an honorary doctorate. He was appointed president of Suffolk Community College in 1997, a post he maintained until his retirement in 2003. Lima has involved himself in many community activities such as an active parish member and trustee of Saint Anthony of Padua in Rocky Point, president of his Sons of Italy lodge and member of the Commission for Social Justice (CSJ).

Mention must be made of the unique educational mission started by Long Island's Henry Viscardi, who originated a school for the severely

handicapped in Albertson. Born with short, twisted legs that wrapped around his abdomen, he spent his first eight years in a hospital where repeated operations finally sufficiently straightened his legs to permit fitting the stumps with padded boots that resembled boxing gloves. When he entered school, his playmates towered over him. Because his arms nearly touched the ground, they called him "Ape Man." Even full grown, he stood three feet, eight inches tall. He went on to become one of the world's leading advocates for the rights of the disabled, advised many presidents, learned to sail boats on the Long Island Sound and to dance and won numerous honorary degrees. The Henry Viscardi School is a teaching community of students, parents, teachers, staff and volunteers dedicated to empowering students with physical disabilities and health impairments. The school works with its students in developing them to be active, independent and self-sufficient participants in society.

MEDICINE

That Italian Americans play key roles in the medical field is demonstrated by Alan D. Guerci, a medical doctor and nationally known cardiologist, who served as president and chief executive officer of Saint Francis Hospital—the world-famous Heart Center in Port Washington. In June 2013, he was named the chief executive officer of Catholic Health Services of Long Island. Likewise, Joseph A. Quagliata, who formerly served as president and CEO of South Nassau Communities Hospital, functions as the chairman of the Nassau-Suffolk Hospital Council's board of directors, a body that comprises the chief executives of the twenty-three Long Island not-for-profit and public hospitals. Dr. Peter Bruno, who received Italian medical degrees, is another example of extraordinary achievement in medicine as the founder of North Suffolk Cardiology Associates, a group of ten coronary specialists that serve the Smithtown area. He is also chief of cardiology at Walter Mathers Hospital in Port Jefferson and a professor at SUNY Stony Brook. In 1958, Dr. E.J. Pesiri joined with Dr. Jerome Zwanger to found one of the area's largest and most respected radiology practices that provided physicians and patients with modern medical diagnostics. Although Dr. Pesiri retired in 2001 and Dr. Zwanger a few years later, the practice continues to serve Long Islanders under the original name.

Doctors Eileen and Joseph DiGiovanna have made a big impact in Long Island's medical community in the field of osteopathy. Two of their children also are doctors of osteopathy.

Before Arthur Gianelli became the president and chief executive officer of the NuHealth System (also called the Nassau Health Care Corporation) in 2006, he was Nassau County's deputy executive for budget and finance. Under his guidance, the Town of North Hempstead recovered its financial footing by eliminating its deficits, improving its credit rating, introducing a federal lobbying program and compiling and implementing a long-term debt management plan. In 2004, Gianelli engineered a refunding of the Nassau Health Care Corporation's outstanding debt, a transaction which was designated as the "Northeast Regional Deal of the Year" in December 2005 by the industry newspaper for public finance. As president of NuHealth System, Gianelli oversees a $545 million teaching facility, which operates the Nassau University Medical Center and other healthcare centers. Gianelli's higher education background includes a bachelor of arts degree in history from Saint John's University, a master of arts degree in political science from Brown University, a master of business administration from Dowling University and master of public health degree from Columbia University. He and his wife are the parents of two children.

One of the most eminent medical doctors who had a tremendous impact in his field on Long Island was world-renowned Dr. Edmund Pellegrino, the founder of the Health Sciences Center at the State University of New York at Stony Brook. A brilliant thinker in the promotion of medical training,

he was faced with the challenge of overcoming the normal bureaucratic obstacles of state bureaucracy and instituted a system that has a lasting legacy. Edmund Pellegrino, from a humble background in Brooklyn, was the son of Italian immigrants whose ethnic background almost prevented him from getting into medical school. According to one account, an Ivy League medical school complimented him on the outstanding grades he received at Saint John's University but declined his application stating in a letter that he would be "happier with" his "own kind." He went to New York University, where he achieved a sterling record and began a fabled sixty-nine-year career in medicine and education that established him as one of the world's most renowned bioethicists. Among his achievements are serving as president of Catholic University of America, founding the Edmund D. Pellegrino Center for Clinical Bioethics at Georgetown University and serving on the International Bioethics Committee of the United Nations Education, Scientific and Cultural Organization (UNESCO). Known as a founder of contemporary medical and bioethics, Pellegrino has authored or edited twenty-two books and more than 575 published articles and chapters in medical science, philosophy and ethics. He was married, the father of seven children and kept working as a doctor until his death in June 2013.

It is interesting to note examples of children following in the medical footsteps of their parents among Italian Americans. For example, after receiving his medical degree from Stony Brook University, Dr. Andrew Serpe joined the Amityville-based medical practice of his father, Dr. Salvatore J. Serpe, who received his medical degree from the University of Bologna. Specialists in internal medicine, both are family practitioners. Likewise, the two children of Columbian-born dentist Dr. Sonia Calamia and her Italian American husband, Dr. John Calamia, have become dentists like their parents.

An even more remarkable example is that of the Di Giovanna family, which has played a significant role in the field of osteopathic medicine since 1959. At that time, the husband-and-wife team of Dr. Joseph A. Di Giovanna and Dr. Eileen I. Di Giovanna founded an office in Massapequa Park on the principles of osteopathic family medicine and began a tradition of personalized, one-on-one family medical care. Dr. Eileen Di Giovanna has taught and written extensively in the field while two of their children, Michael and Geri, have also become doctors of osteopathy and practice their profession in a state-of-the-art facility opened by the Di Giovanna family in North Massapequa.

LAW

Anecdotal observation indicates that Italian Americans are well represented in Long Island's legal profession, operating hundreds of individual law offices as well as being principals in large firms. A sampling of a few prestigious law firms either started by Italian Americans or in which they are managing partners is instructive.

Albanese and Albanese

The Albanese and Albanese law firm was established in 1949 by Vincent M. Albanese. One of the region's preeminent full-service law firms, it has provided a full range of legal services to major financial institutions, insurance companies and real estate developers, among others. Three members of the Albanese family are partners, along with several other partners. Former county executive Thomas Gulotta joined the firm after retiring from elective office.

Forchelli

Formed in 1976 by Jeffrey D. Forchelli, Forchelli, Curto, Deegan, Schwartz, Mineo, Cohn & Terrana, LLP, enjoys a reputation as one of Long Island's leading full-service law firms. It has been successful in representing clients in real estate, land use and zoning, tax, trusts and estates, tax certiorari, corporate and commercial and litigation. The firm has grown from a three-member firm to nearly fifty attorneys who handle complex matters for a broad client base. The firm has offices in Uniondale and Melville.

Rosella and Savino

Holding degrees from Hofstra University and Fordham University, attorney Ralph Rosella is a member with Lazer, Aptheker, Rosella & Yedid, PC, in Melville, New York, serving Suffolk County, while William Savino, considered by some as the most powerful attorney on Long Island, is managing partner of the William Savino, Rivkin Radler LLP firm. He

Columbia Police Association of Nassau County, a fraternal organization within the department of law enforcement personnel of Italian American heritage. *Courtesy Carmine Soldano.*

has engaged in high-profile cases and has been appointed to sit on the Nassau County Judicial Panel as a member of the New York State Judicial Screening Committee.

Columbian Lawyers of Nassau County

Attorneys of Italian heritage have formed organizations within their profession in both Long Island counties. Created in 1965, the Suffolk County Columbian Lawyers Association was begun by a handful of attorneys who recognized their underrepresentation in the Suffolk County bench and in other leadership positions in government and politics. The association grew rapidly in the 1970s with an annual installation becoming the highlight of the legal community's activities. Beyond social activities, the association publicizes the rise of group members in county judiciary ranks as well as

their influence in the Suffolk County Bar Association. The large number of lawyers in Nassau County prompted them to found their own organization: the Columbian Lawyers of Nassau County in 1977. It lists more than four hundred attorneys and jurists as members who meet on a regular basis and who partake in numerous events sponsored by the association revolving around their ethnic heritage.

Columbia Police Association of Nassau County

After initial resistance from the police commissioner, Italian American members of the county's police and detective department formed the Columbia Police Association of Nassau County in 1962. Over a fifty-year period, the association has held a number of social events such as "Italian Day" picnics, golf outings and dinners in which guest speakers give presentations on various subjects, particularly dealing with Italian culture. In addition, the association raises funds for scholarships and confers awards to esteemed Italian Americans from within and without of the police ranks.

A strong interest of the association is that of promoting the advancement of Italian Americans within the police department. A major example of this interest occurred when, together with the Patrolman's Benevolent Association under the direction of Edward Lecci, the association collaborated in urging that an Italian American should be appointed police commissioner—an event that transpired when Samuel Rozzi became Nassau County police commissioner in 1974.

Labor Unions

Descendants from an overwhelming proletarian background, it was inevitable that Italian Americans would soon take their place as leaders among the more influential labor unions on the island—a development that will be reviewed in the following examples. Some of the leaders were of an earlier generation who lived on Long Island while serving as union leaders for New York City labor organizations. A case in point

was E. Howard Molisani, who was brought up in a family with strong union ties—his father had been president of a local garment workers' union affiliated with the International Ladies Garment Workers Union (ILGWU). A resident of Port Washington, E. Howard Molisani was a graduate of Fordham University and Brooklyn Law School and was elected a vice-president of the ILGWU. He had a forty-year career in the labor movement. He was involved not only in the labor union but also in its efforts to improve the image of Italian Americans.

Richard Ianucci

Richard Ianucci, who was raised in a union household in Brooklyn, graduated from the City University of New York, Brooklyn College, earned a master's degree from Hofstra University and a labor studies certificate from Cornell University. In 1970, he began to teach elementary school in the Central Islip public schools, where he taught for thirty-four years and where he became active from the outset by joining fellow members on strike in his first year on the job. Ianucci was elected building representative in 1971 and served as vice-president of the Central Islip Teachers Association from 1976 to 1996 and president from 1996 to 2004. He was elected the second vice-president of New York State Union of Teachers (NYSUT) in 2004, first vice-president later that year and president of the union in 2005. He has continued to be a forceful voice on behalf of teachers at both the state and federal levels throughout his tenure while his labor organization, which includes teachers in public and private schools and college, as well as healthcare workers, has grown to over 600,000. As NYSUT president, Iannuzzi is a vice-president of the American Federation of Teachers (AFT) and vice-president of the New York State American Federation of Labor and Congress of Industrial Organizations (AFL-CIO). He also is a delegate to the national AFL-CIO and co-chair of the New York State Labor-Religion Coalition. He has received a number of honors for his commitment to labor, including the Ellis Island Medal of Honor.

LaMorte

There are many examples of Italian Americans who made their marks in the labor movement within the confines of Long Island. One was Nick LaMorte, whose journey from laborer to leader in the organized labor community began when he was only nineteen and was hired to work as a cleaner in the Farmingdale School District as a means of earning tuition money for Hofstra University. When the Farmingdale School District adopted policies to diminish benefits for janitorial help, he launched into an activist role in his union, becoming chairman of his unit, which succeeded in obtaining a favorable contract. He worked his way up, eventually becoming vice-president of CSEA's Nassau Educational Local 865 that represented workers in twenty-six school districts. LaMorte was elected president of his union local in 1986 and served two terms, while simultaneously becoming chair of the CSEA Special Statewide School Committee that represented thirty-five thousand people. In 2004, he became president of the entire Long Island Region of the CSEA and won reelection repeatedly. As a committed member of the Long Island United Way, LaMorte also is involved in efforts to aid the community.

Gary DelaRaba

Gary DelaRaba, who served as president of the Nassau County Police Benevolent Association (PBA) for two decades, was one of the most powerful labor leaders in Long Island's recent history. Joining the ranks of the county police force in 1971, he became a PBA officer in 1976 and then president of the union in 1988. He made an immediate impression with what was regarded as a "brilliant and innovative concept for lawyering police unions"; that is, hiring law firms that concentrated on specialties rather than on one umbrella law firm. Steadfast on behalf of the interest of his membership, his commitment frequently found him confronting both Democratic and Republican Nassau County executives as well as the daily newspaper, *Newsday*. He continued as union president for twenty years, during which time he negotiated four contracts favorable to police officers, thereby amassing a record that earned a ranking of eighteenth on the 2007 Long Island Press Power list before he retired in 2008.

Jerry Larichiuta

In 2005, Jerry Larichiuta became president of the Nassau County Civil Service Employees Association Local 830 and thus spokesman for ten thousand public employees. A father of three, he was a longtime cook in the Nassau County Correctional Center who led the association during a time when the wealthy county, then under state watchdog constraints, began cutting civil service jobs to meet ongoing budget shortfalls. Speaking on behalf of his people, Laricchiuta resisted the county executives of both political parties in order to defend against their proposed wage cuts and job eliminations that would hurt his union members. A registered Republican, he did not hesitate to oppose Republican Party members of the county legislature for proposing solutions to the fiscally troubled county that called for civil service layoffs.

John R. Durso

Brooklyn-born John R. Durso began his career humbly as a deli clerk with the Waldbaum's Supermarkets chain in 1970. From that modest position, he advanced to become store manager of a Waldbaum's Supermarket. Currently, he is president of Long Island's Federation of Labor that includes over 160 unions affiliated with the AFL and simultaneously is president of the Retail, Wholesale and Department Store Union (RWDSU/UFCW) Local 338, the largest affiliate in the powerful United Food and Commercial Workers International. Durso joined the staff of Local 338 in 1984, beginning as an organizer and business agent in 1997, followed by becoming an assistant to the president and then president of the local in 2002. Under his leadership as president of the Long Island Federation commencing in 2005, the organization's membership increased by 40 percent and currently is estimated at 250,000, representing a wide range of union workers: teachers, technicians, public employees, painters, bus drivers, bricklayers, retail, auto, janitorial, utility, healthcare and construction workers. The federation conducts local political activities, such as lobbying county and town governments and participating in local elections, as well as communicating local legislative issues. It communicates various issues to its affiliated local unions, helps to mobilize members when needed and supports unions during organizing drives. In addition to union

responsibilities, Durso has served the community in other ways, such as functioning as a member of the Nassau Community College Board of Trustees and a member of the Town of Hempstead Labor Commission. Durso, who is married and the father of four children, is the recipient of the Ellis Island Medal of Honor.

Chapter 12

POLITICS

Perhaps more so than any other area of community activity, politics finds Long Island's Italian Americans more visible and noticeable. Merely to list those who have attained the highest political positions locally is to underscore their prominence. Four of the five Nassau County executives (the highest rank in county government) since 1962—thirty-eight of fifty-one years—have been Italian Americans: Ralph Caso, Thomas Gulotta, Thomas Suozzi and Edward Mangano. The list of Italian Americans who served as Suffolk County executives is shorter, but at least two Suffolk County executives, Michael LoGrande and Steve Levy, had Italian ancestry. Italian names, furthermore, are abundant with regard to town supervisors, village mayors and other local positions. One example is to be found in Huntington, where a succession of Italian Americans succeeded each other as town supervisors beginning with Antonia Rettaliata, who served in the state assembly for nine years before winning the supervisor's job in 1987, defeating Stephen Ferraro, who defeated her for the post two years later in 1989. In 1993, Frank Petrone won election as town supervisor as a Republican but changed his registration to become a Democrat soon afterward. As of this writing, he is approaching two decades in that office. Another example of an Italian American who wielded political clout for an extended period is Caesar Trunzo, who served for a time as Islip town Republican leader and also served thirty years in the New York State Senate. Even more impressive in terms of longevity is the career of Smithtown supervisor

Left: Ralph Caso, the first Italian American Nassau County executive.

Bottom: Nassau County executive Thomas Gulotta speaking at Italian Night in Eisenhower Park.

Patrick Vecchio, who has served in his position since 1978, making him the longest presiding supervisor in New York state. Eighty-two-year-old Vecchio, a former distinguished member of the New York City Police Department, an army veteran and holder of a bachelor's degree from Saint John's University, has served for thirty-three years, beginning as a Democrat but eventually changing to Republican.

The Town of Hempstead is the kingpin of three towns and two small cities that includes Nassau County. The position of presiding supervisor of Hempstead automatically confers major influence on those who attain the position. Ralph Caso was the first of his nationality to become Hempstead town supervisor, serving from 1961 to 1965, and Hempstead presiding supervisor, serving from 1965 to 1970. A Republican, he added luster to his political career by becoming the first Italian American to be elected Nassau County executive in 1970 and became the Republican nominee for New York lieutenant governor in 1974. Republican Alphonse D'Amato followed a similar route, becoming Hempstead presiding town supervisor in 1977. However, D'Amato went beyond Caso by using that post to run and win the New York United States Senate seat in 1980—thereby becoming the first Italian American to represent New York in that august legislative body. Thomas Gulotta was still another American of Italian descent to follow the Hempstead political path to success in high office. Bearer of an illustrious name—his father had a distinguished career as the first Italian American to win countywide office when he was elected district attorney of Nassau County in 1945—Thomas was born and raised on Long Island. He was the possessor of an Ivy League law degree from Columbia University and followed the script methodically arranged by the executive committee of the Nassau County Republican Party. He was elected to the New York State Assembly in 1976 and remained there until 1981, when he was chosen to be presiding supervisor of the Town of Hempstead. Nassau County executive from 1987 to 2001, Gulotta was rumored to have aspirations to run for higher state office but retired from elective politics when his term expired. His brother Frank Gulotta Jr. is a supreme court justice in Nassau County.

REPUBLICAN PARTY POLITICS

Much of the Italian American success in Long Island Republican Party politics can be attributed to the role Italian Americans have played in party machinery; that is, as party chairmen in Nassau's townships as well as county leaders. The Carlino family is one of many illustrations of this phenomenon. Moving to Long Beach from Manhattan's lower east side, Lorenzo Carlino served as the Republican Party leader of Long Beach from 1937 to 1943. After his death, his son Joseph, newly graduated from Fordham Law School, succeeded him in the post. Always immaculately dressed, at age twenty-seven, Joseph was elected to the New York State Assembly in 1945. He served as majority leader from 1955 to 1959 and then became Speaker of the assembly, truly one of the first powerful Italian American Republicans in New York. A moderate Republican who developed an unparalleled working relationship with Democrats, Joseph led the state to embark on major highway and state university improvements, as well as increase aid to public schools. He was the first Republican from Long Island to be chosen Speaker of the assembly in one hundred years and the first of his nationality to attain that post—clearly a reflection of the growing importance of Italian Americans politically. Carlino's impressive record lent itself to speculation that he might run for governor; however, the dream collapsed when he surprisingly lost his reelection bid to the assembly in 1964.

Apparently, once the working class moved to the island, pragmatic considerations triumphed—they and their children realized that the Republican machine was the vehicle to ensure a job or access to government services—thus, the appeal of the Republican Party to the overwhelmingly proletarian, labor union–oriented Italian Americans. In sharp contrast with the big cities that usually witnessed an alliance between the Democratic Party and organized labor, in Nassau County it was the Republican Party and organized labor that formed a tandem. For decades, the labor movement in suburbia supported the election of Republicans who made sure that government provided good-paying jobs based on favorable contracts for the public sector and pro-labor legislation for the private sector unions. It was not unusual for union members on Long Island to register as Republicans and even serve as committeemen because of the conviction that the Republican Party would protect their interests. Thus unfolded the curious phenomenon of city-born union activists raised in working-class families changing their political allegiance upon moving to the suburbs. What renders this phenomenon

Long Island Italian American judges discuss their careers at a meeting of the Long Island Chapter of the American Italian Historical Association in the 1960s.

even more interesting is that this occurred despite the fact that over the years since World War II, organized labor depicted the national Republican Party as anti-labor.

Di Sibio

Among the most effective Italian American leaders to harness and wield political clout on a local level was Peter Di Sibio of Inwood in Nassau County who came to the attention of legendary Republican leader J. Russell Sprague in the 1940s. Sprague, apparently responding to Democratic inroads in the area, named Di Sibio Republican leader in Inwood, where the newly minted party official worked in his family's plaster business until he got a new job as Hempstead highway superintendent while simultaneously starting a public relations firm. Di Sibio held his Republican leadership post for more than half a century as he faithfully delivered the GOP vote that in turn led to enormous political influence, as well as to financial benefits for him and his family. One of his sons, Nicholas, for instance, obtained lucrative legal work

representing Hempstead and Oyster Bay in workers compensation cases. Becoming the unsalaried chairman of the Nassau County Bridge Authority, Peter named a number of friends and relatives to jobs. Born in Inwood in 1908, he lived on a street that was named after him when he died in November 1993—widely regarded as political legend in his time.

Margiotta

Joseph Margiotta was undeniably the most powerful Republican Party leader of his time. Born in 1927, he was a student-athlete at Hofstra University who raised huge funds for his alma mater—he later had the satisfaction of witnessing the institution name its field house Margiotta Hall in his honor. In 1958, he was living in Uniondale when he became counsel to state senator Edward Speno, his predecessor as Nassau County chairman from 1965 to 1968. In 1965, Margiotta became a state assemblyman and soon chairman of the Hempstead Republican Party and the county committee, promoting the interests of suburban white middle-income Catholic voters over emergent urban voices. He became Republican Party chairman of Nassau County in 1976, at which time he left the assembly, choosing to work full time as party chairman, a deceptive title since it implies that Margiotta was merely one of the sixty-two county party leaders in the state. He was, in fact, the head of the most powerful Republican Party organization in the country. Under his direction, the Nassau Republican machine became a massive, well-oiled organization, stronger and richer than the others, and he became the most effective political boss of the era, constantly cementing his leadership role and choosing protégés who rose to political prominence, while also playing a direct part in shaping even mundane decisions. At the zenith of his power, he was able to force a weakening of zoning powers for Governor Rockefeller's Urban Development Corporation, protected the county schools in the state budgets and blocked the planned Oyster Bay bridge to the mainland. He turned out record New York votes for the presidential candidacies of Richard Nixon in 1972 and Gerald Ford in 1976, engineered North Hempstead supervisor Sol Wachtler's elevation to the state court of appeals and helped make Perry Duryea assembly speaker as well as Ralph Caso and then Francis Purcell Nassau executives. In addition, he advanced the political careers of former United States senator Alphonse M. D'Amato, majority leader of the New York State Senate Dean Skelos and his successor as party leader, Joseph Mondello. It was estimated that during Margiotta's tenure,

most of the two thousand Nassau County Republican committee members were on local government payrolls. The system attributed to Margiotta made the Republican Party very wealthy; it employed twenty-three full-time workers—in size as large as the staff of the New York State Republican Party—who enjoyed high salaries, medical and dental benefits and pension plans. Of course, these administrative employees and government workers in smaller governmental entities controlled by Republicans were expected to donate 1 percent of their salaries to the party, buy tickets to fundraisers and work for the election of party candidates.

Inevitably, county workers complained about kicking back part of their salaries to the party and being forced to cooperate with it in other ways such as buying tickets for fundraising functions. Good government groups and *Newsday* heavily criticized the practices, leading eventually to charges of violating federal law. Following a hung jury trial, a retrial convicted Margiotta on six counts of mail fraud and extortion, leading him to resign in 1983 and thereby bringing to an inglorious end his sixteen-year party control. He was sentenced to prison, where he served fourteen months.

D'Amato

For all Italian Americans' successes in electoral politics that elevated them to some of the most prestigious offices in New York State, where they constitute the largest single nationality group, it is remarkable that New Yorkers have elected only one Italian American to the United States Senate: Long Islander Alphonse Marcello D'Amato. Accordingly, his career warrants further examination and study. Born in Brooklyn in 1937, he moved with his family to Island Park in Nassau County. D'Amato graduated from Chaminade High School and then Syracuse University, where he also earned a law degree. Possessed of a garrulous and extroverted personality, after D'Amato met Long Beach Republican leader Joseph Carlino at a March of Dimes fundraiser, the young man became involved in Republican local politics, beginning with the appointive position as public administrator in Nassau County and quickly climbing up the ladder to a string of other positions: receiver of taxes of Hempstead, town supervisor of Hempstead and presiding supervisor of the Town of Hempstead. While impressive in suburbia, these posts seemed insignificant and too obscure to serve as background to challenge liberal icon Senator Jacob Javits, the *éminence grise* of the Republican Party who was seeking reelection to his

fifth term. But D'Amato had street smarts, the savvy gut instincts and basic common sense that enabled him to see possibilities—Javits was not in the best of health. D'Amato bested the vulnerable Javits to win the Republican nomination, leaving Javits with only the Liberal Party line, while equally liberal Elizabeth Holtzman gained the Democratic Party nomination. While the latter two split the vote, D'Amato squeezed through with a 45 percent plurality.

Much to the chagrin of senior senators who expected newly elected colleagues to remain in the background and learn Senate procedures from them, D'Amato pounced on the opportunity to inject himself immediately into the fray. A newcomer to the Senate, he did not let his freshman status keep him from unabashedly thrusting himself into the issues before that body. Not a gifted orator or intellectual compared to other distinguished Senate colleagues, he nevertheless was unafraid to take them on, employing a brash style as he fought aggressively for the practical interests of his constituents, especially highway programs and housing projects—a practice that earned him the title of "pothole senator." While his detractors used it as an epithet of derision, he embraced it proudly as being effective in getting things done. His approach was to act as an interceder, a fixer of problems and "a man of the people who acts as [a] benevolent intermediary in exchange for political gratitude, a master of the quid pro quo." D'Amato soldiered on in his self-appointed intercessory role, gaining notoriety for his near record-breaking filibuster. He spoke for twenty-three hours and thirty minutes in 1986 to stall a military appropriations bill that cut funding for a warplane built by a company headquartered in his district. At a loss for something to talk about beyond his relatively straightforward opposition to the bill, D'Amato read from the phonebook of the District of Columbia. His effectiveness helped him to win reelection, handily garnering nearly 57 percent of the vote in 1986 against a weaker Democrat, Mark Green.

While he broadened his interests to include national issues such as the drug problem and aid to Israel, his opponents nevertheless continued to assail him as the beneficiary of a corrupt politic machine and on ethics issues. But D'Amato showed that he could change on certain issues. Thus, his vigorous denunciation of discrimination against gays and strong support for funds to combat AIDS brought him some unlikely support within the gay community. For a time, it appeared that D'Amato's Democratic opponent would be Representative Geraldine Ferraro, who made history as the first woman and first Italian American

candidate for vice-president. The prospect of two major Italian American politicians contesting for a U.S. Senate seat was potentially historic. It prompted *Newsday* Pulitzer Prize–winning journalist Adrian Peracchio to make a trenchant observation about the state of Italian Americans in politics, in which a triumvirate had emerged as national figures: Mario Cuomo, Geraldine Ferraro and Alphonse D'Amato. As Peracchio saw it, regardless of the outcome of the Senate race, "the ebb and flow of American politics will have undergone an inexorable sea of change for Italian Americans this year…all from the ethnic cauldron of New York." Beset by innuendos concerning her husband's finances, Ferraro pulled out of the race, which set the stage for another Democrat of high profile, Robert Abrams, New York attorney general, to run against D'Amato. It proved to be a close race, but after a long, arduous campaign supported by former mayor Edward Koch and Hasidic Jewish leaders, D'Amato won the 1992 race.

By 1998, the odds against D'Amato were becoming heavy indeed. Always at a disadvantage because of the heavy Democrat enrollment in the state and because of ceaseless insinuation of seedy politics, he now faced sturdier opposition in nine-term Congressman Charles Schumer, who could stand toe-to-toe against him in debates. The result of the frantic and bruising campaign was that D'Amato was defeated in his quest for a fourth term in the Senate. D'Amato continues to remain in the public because of his highly successful firm Park Strategies that currently is one of the top-ten lobbying firms in New York State. D'Amato also occasionally endorses Republican candidates for local office.

Caracappa

The establishment of political dynasties or near dynasties in which particular families repeatedly produce notable politicians from their ranks has applicability to Long Island Italians in some local communities. Conservative Party member Rose Caracappa of Selden, a feisty and vociferous member of the Suffolk County legislature, became legendary for her hardball ways with other politicians. At one point, with support from the Right-to-Life and the Republican Party, she defeated a Democrat female prochoice abortion foe. At the time of her untimely death in 1995, she had laid the groundwork for her two sons to wield political influence locally. Soft-spoken and well tailored, twenty-seven-year-old Joseph Caracappa, a heavy equipment operator, succeeded his mother in holding a seat in the Suffolk

County legislature. He proved to be so effective that twice he ran unopposed. Impressing his colleagues with his talent, he rose to presiding officer of the Suffolk County legislature until Democrats took the majority in 2006. For a time, rumors persisted that he might run for Suffolk County executive; however, he left the political arena in favor of private practice. Rose's son Nick Caracappa, a maintenance worker, is a much more blue-collar type whose political clout resided in labor unionism—he headed a 350-member union at the water authority.

Acampora

The Acampora name has led two members of that clan to political success in Suffolk County. Blunt-speaking Henrietta Acampora, a retired navy nurse, had a twenty-two-year career in Brookhaven Town government, first as deputy town clerk and then functioning as the first female supervisor of the town, winning reelection four times until she retired in 1990. Rather than merely going along as just another politician, she effectively established herself as a strong and vocal opponent of increased taxes. Patricia Acampora, Henrietta's daughter, would eventually enter politics after divorcing her first husband and marrying Alan Croce, who had his own political career as deputy sheriff, state correction commissioner and state parole commissioner. Before Henrietta passed away in 1995, her daughter Patricia, carrying the Acampora pedigree, became an active political figure in Suffolk County. Patricia became Brookhaven Republican Party chairperson and a ten-year member of the state assembly before being appointed as a member of the New York State Public Service Commission.

Prudenti

Credited with building five thousand Long Island homes, wealthy and ambitious Anthony J. Prudenti became a Republican powerhouse in the early 1980s with his success in backing Peter F. Cohalan, who became Suffolk County executive. While his aspiration to become New York State Republican Party chairman failed to materialize, Prudenti did see his daughter Gail Prudenti Cimini attain an impressive position in government. Gail became a lawyer, Suffolk County assistant district attorney, surrogate

law clerk, justice for the appellate division and chief administrative judge of the Courts of New York State.

Oyster Bay

In Oyster Bay Town, the family-political-connection phenomenon may be found in the Saladino family. The son of Italian immigrants, Joseph Saladino was born in Brooklyn, where he went to school, and he had two tours of military duty as a soldier and as a marine. When he moved to Massapequa, he became active in community affairs, a founder of the Columbian Lawyers Association and president of the Massapequa Republican Club. He was elected to the Town of Oyster Bay board and then a state supreme court judge. His son Joseph Saladino Jr. followed in his footsteps, becoming a lawyer and member of the New York State Assembly. Another son, James

James Saladino, Conservative Party chairman, Riverhead; Judge Angelo Roncallo, former congressman; Judge Joseph Saladino Sr.; and Assemblyman Joseph Saladino. *Courtesy Ginny Ewen.*

Saladino, has been an active leader in Suffolk County's Conservative Party. The near-dynasty phenomenon also applies to the Venditto family, which includes John Venditto, supervisor of the town from 1998 to the 2013, and his son Michael Venditto, who in 2012 was chosen to become a member of the Nassau County legislature in a special election.

Suozzi

The preeminent example of Long Island Italian American political dynasties is that of the Glen Cove Suozzi family. It is singular with respect to the power of a political name not only locally but also beyond. No fewer than four members of the clan—two brothers and their two sons—have been mayors of the City of Glen Cove. It began with Joseph A. Suozzi, who emigrated from an obscure town in Italy, served with distinction as a navigator in the air force during World War II, graduated from Harvard Law School and became the youngest judge in the country before he was elected mayor in 1954. He failed to win the countywide post as supervisor but was elected to the Supreme Court of New York State, remaining in the post until his retirement. Other members of the Suozzi clan who have been elected mayors of Glen Cove include Joseph's younger brother Vincent (Jimmy) Suozzi, elected in 1973 and 1984, his son Thomas, elected from 1993 to 2001, and Vincent's son Ralph Suozzi, elected in 2005 and currently remains in that post. To say that the Suozzi name has a Kennedyesque aura is not an overstatement

The political goal of winning countywide office that eluded Joseph came to fruition in his son Thomas, who won election as county executive in 2001 and held the post until 2009. Thomas Suozzi, scion of an illustrious Long Island political family with Italian and Irish ancestry, became the first Democrat in thirty years elected to the post of county executive. He made such a favorable impression that, in 2005, *Governing* magazine called him "Public Official of the Year," citing his initiatives and innovative leadership—high praise for a rising young politician whose successes were also deemed instrumental in making Democrats the majority in the Nassau County legislature. As a consequence, he was in a position to seek higher office, including the governorship, but failed to win the Democratic primary for governor. Suozzi continued to work as county executive, running for reelection in 2009 but, notwithstanding the high marks he had received, was defeated by Edward P. Mangano, a Republican.

Mangano

Nassau County executive Edward Mangano, fourth chief executive of Italian ancestry. *Courtesy Edward Mangano.*

One of three children born to Rachel and John Mangano, Edward was raised in Bethpage and attended Hofstra University, where he received both undergraduate and law degrees earning tuition money by working as a janitor. After a successful career in the printing and publication field, he entered politics and served as a county legislator for many years, where he made his mark on conservation issues. Since he took office as county executive, Mangano has dealt with tax issues, supporting Governor Andrew Cuomo's tax limit plan and dealing with a large budget deficit. In 2011, he received the Italian Heritage Award issued by the Columbia Association. Approaching 2013, Mangano received his highest approval since taking office, a feat based on his leadership role in dealing with Hurricane Sandy.

There is an ongoing debate over the continuing strength of the ethnic factor among Long Island's Italian Americans in the realm of politics. It has been suggested that because the Italian Americans of the 1990s were largely third and fourth generation, they no longer favor the Republican Party as in prior years. However, many others maintain that Italian American adherence to the GOP was never as monolithic as portrayed. A special *Newsday* inquiry into the subject in 1972 found every prominent political figure rejecting the notion that an Italian name would lead automatically to ethnic support for a candidate.

DeMatteis

Guilt by association raises its ugly head periodically. One case that illustrates this is that of the DeMatteis Construction Corporation, which was started by Leon DeMatteis in Brooklyn in 1918 and moved to Elmont, Long Island, in 1949. It is one of the largest family-owned and managed construction firms in the area that continues to be run by family members—now into the third generation that participated in the flourishing postwar construction of suburbia, building hundreds of millions of square feet of residential and commercial real estate and public projects, especially public schools. It is well represented in the New York region, as well as nationally and internationally, with a résumé that boasts of building a residential tower at United Nations Plaza, a similar facility for the Museum of Modern Art and the modernization of LaGuardia Airport.

Notwithstanding this impressive history, in 1991, despite the fact that it had presented the lowest sealed bid and had been awarded a contract for a municipal construction job, New York City revoked a $1.2 million contract with the company, charging that it had concealed and altered reports about possible ties to organized crime figures. Simply put, the city comptroller suggested a link between organized crime figures with Italian names and the DeMatteis firm even though the company had executed work projects satisfactorily previously. Company owners, however, had the will, the resources and the strong support of Long Island Italian American organizations and effectively demonstrated that there had never been a connection between the two and that Frederick DeMatteis, who was then company president, was a bona fide businessman who was victimized because of his Italian ancestry. Vindication for DeMatteis, and by extension Italian Americans, came after an appeal to New York State's Supreme Court, when one of its justices concluded that the denial of the contract to DeMatteis was based on spurious grounds that reflected ethnic prejudice. Other than innuendo, speculation and guilt by association, particularly against one with an Italian surname, there was simply no evidence that De Matteis was involved in corrupt association.

Appreciative of support from the community, in 2001, Frederick and Nancy DeMatteis established a family foundation that has been generous in its support of education- and health-related issues. Among the generous donations was one that established the Nancy and Frederick DeMatteis Pavilion at Saint Francis Hospital in Roslyn, the largest expansion project in the hospital's history.

As we have already seen, Italian ancestry is well represented in Long Island politics; nevertheless, a degree of anti-Italianism may still be found, not in the blunt fashion of yesteryear, but in the more subtle ways of non-inclusion, stereotyping and guilt by association. Pockets of anti-Italianism remain, and even though conditions have improved significantly, discrimination occasionally surfaces. Stereotyping remains and is manifest in slurs against the ethnic group attributable to television shows like *The Sopranos* and *Jersey Shore*. The movement to offer and encourage Italian language studies is an ongoing effort, seeming, on the one hand, to succeed in many school districts yet experiencing setbacks in others. Early in 2013, a North Shore school district in Nassau County replaced Italian with Mandarin as meeting language requirements for graduation, although Italian will still be an elective offering.

MOVERS, SHAKERS AND CELEBRITIES

A Sampling

JOURNALISM

Newsday, which began as a tabloid daily in 1940, joined the *Long Island Press* as one of the daily newspapers covering Long Island. When the latter ceased operations in 1977, it left the newspaper field to *Newsday*, which sought to gain respectability for responsible reporting and nonbias when it came to ethnic groups. For a newspaper to have staff members with Italian surnames does not ensure objectivity, nor is it to be assumed that merely because of their ancestry such personnel should automatically pass as expert observers. With that caveat, we can explore the subject. Since Italian Americans represented 25 percent of its potential readership, it is pertinent to review the relations between *Newsday* and the ethnic group, at least with respect to personnel. Although hard data is lacking, anecdotal impressions suggest that while Italian names do not abound among its reportorial staff, there were and continue to be identifiable Italian names as reporters and administrators on its staff. There have been at least two Italian editors-in-chief, Anthony Marro and John Mancini. Marro, who joined *Newsday* in 1968 after a year of journalism school at Columbia University, impressed colleagues with his tenacity, even to the extent of jumping off the Chappaquiddick Bridge to check the currents of the water while covering Senator Theodore Kennedy's car crash in 1969. He rose up

the ranks from reporter to managing editor to editor-in-chief during his thirty-five years at *Newsday* and retired in 2002. After a stint as editor for the *New York Observer*, in 2004, Mancini became chief editor of *Newsday*. His was a more difficult tenure, as the newspaper was experiencing economic rough waters along with change of ownership that, at one point, led to Mancini's resignation over cost-cutting reductions, but he returned to the post shortly afterward. Faced with shrinking revenue, Mancini sought to transform the newspaper to the digital age—a difficult transition. He left his position in 2010 to become an assistant managing editor for the Associated Press.

Over the years, several Italian Americans have had successful careers as writers for *Newsday*, including Paul Vitello, Adrian Peracchio and Marie Cocco. Beginning his twenty-four-year *Newsday* career in 1984, Vitello wrote numerous observations about Long Islanders in addition to voicing criticism of the television series *The Sopranos*, while Adrian Peracchio, a member of the editorial board, specialized in covering foreign affairs at *Newsday*. Peracchio also wrote incisive pieces on Italian American stereotypes. Syndicated columnist Marie Cocco has highlighted issues of importance to Italian Americans—for example, her November 17, 1999 column reminded readers that Italian Americans had been denied civil rights during World War II. Rita Ciolli began her *Newsday* career in 1972 as a summer intern while studying at Fordham University. During her career with the newspaper, she has covered courts in Mineola, national events in the paper's Washington bureau—including Geraldine Ferraro's vice-presidential candidacy—and editorial matters such as political endorsements. She earned a law degree at Georgetown University, is the current editor of the editorial page and is married to Peter Gianotti, *Newsday*'s restaurant critic.

Mention must be made about *Newsday*'s extended emphasis on the lives of Long Island's Italian Americans—a rare focus among metropolitan newspapers in recent years. This occurred during the years when *Newsday* supplemented its offerings with a Sunday magazine edition; in effect, it recognized the growing importance of Long Island's Italian American population, which already accounted one in four residents. The June 4, 1972 feature edition, devoted exclusively to Long Island Italians, is noteworthy because it not only highlighted their emergence in various communities with portraits of individual families but also sought out their views on issues meaningful to the ethnic group.

SPORTS

Space limitations permit only a sampling of a large number of Long Island Italian Americans who made their marks on society through sports. Thus, although not comprehensive, it demonstrates an interaction that reflects assimilation alongside ethnic consciousness.

Basketball

The youngest of seven children, Tom Gugliotta attended Walt Whitman High School in Huntington, where he excelled in basketball. After college ball at North Carolina State University, he became a professional basketball player, and over a long thirteen-year career, he played for a number of teams.

Bowling

Giuseppe (Joe) Falcaro, a flamboyant and colorful character both on and off the lanes, brought showmanship to bowling. Starting out as a pin boy earning a dollar a day, he went on to a forty-year career, during which he had sixty-nine perfect games. At one point, he defeated the reigning champ and claimed the championship for himself. He taught women to play the game, made movie shorts and went on tours. Falcaro lived in Lawrence, where he owned a swank bowling alley that bore his name, and died at age fifty-five in 1951.

Italian-born Andy Varipapa, champion bowler who lived to be ninety-three years old, lived part of his life on Long Island as the operator of a bowling alley in Hempstead, bowling instructor and performer. Famous for his trick shots, he made demonstration movies in Hollywood. Yet he was also a champion bowler and winner of prestigious tournaments. Falcaro and Varipapa formed a dominant doubles team for many years that contributed to the growth of the sport.

Baseball

Craig Biggio grew up in Kings Park, Long Island, where he excelled as a multisport varsity athlete. Although he was awarded the Hansen Award,

Westbury's mayor Ernest Strada is welcomed by the mayor of Durazzano, Italy, the place of origin for many who settled in the Long Island town.

which recognized him as being the best football player in Suffolk County, his passion lay with baseball; in particular, playing college baseball for Seton Hall University. He played professional baseball for the Houston Astros, first as a catcher and then as a second baseman. Biggio finished his career with 3,060 career hits, 668 doubles, 291 home runs, 1,175 RBIs, 414 stolen bases and a .281 batting average and will be eligible for induction into Baseball's Hall of Fame in 2013.

Frank J. Viola Jr., born in East Meadow, Long Island, was a left-handed major-league pitcher for many years. He attended East Meadow High School and played baseball for Saint John's University, which led to a contract with the Milwaukee Twins. He played major-league baseball from 1982 to 1996, was a three-time All Star and has been inducted into the Milwaukee Twins Hall of Fame. He had an impressive 3.75 lifetime ERA, a record of 176 wins to 160 losses in 421 games, 16 shutouts and 74 complete games.

Football

Elmont, Long Island's Vincent Testaverde was an All-American quarterback for the University of Miami, winner of the Heisman Trophy in 1986 and the first overall pick in the 1987 NFL draft. He played professional football for a number of teams, including the New York Jets. Ironically, the six-foot, five-inch athlete was not a starter on the Sewanhaka High School until his senior year. Vincent, the son of a construction worker, was born in South Brooklyn. When he was one year old, the family moved to Elmont, where people of Italian ancestry formed the largest ethnic group. He grew up in the ethnic neighborhood and frequented pizzerias and Italian bakeries on Meacham Avenue. Before his career came to a close, Testaverde had played professional football for several teams and achieved franchise records.

Writers

Di Donato

Among the most outstanding authors of Italian ancestry who have lived or written about Long Island were Pietro Di Donato and Mario Puzo. Donato, it might be added, was, as his son described, a bricklayer who also wrote books. He achieved lasting fame for his novel *Christ in Concrete*, a straightforward recounting of the travails of Italian American construction workers, particularly his father, who was killed in a construction-work accident. His father's death compelled Donato to quit school at age twelve to support his family working as a mason and a bricklayer, and eventually the family moved to Northport, Long Island.

Pietro's formal education was limited, although he took night classes at City University of New York and became so deeply impressed with Emil Zola's works that he was inspired to write about his father. *Christ in Concrete* soon became a classic hailed universally by critics as a metaphor for the immigrant experience in America. It became a Book of the Month Club selection, remained on bestseller lists for months and was made into a film titled *Give Us This Day*. His later books included *Life of Mother Cabrini* (1960), *Three Circles of Life* (1960), *The Penitent* (1962) and *Naked Author* (1970) and did not achieve critical success. He was still using bricks to build at age eighty, when he died at his Setauket home in 1992.

Puzo

Mario Puzo was born into a poor family in 1920 in the Hell's Kitchen neighborhood in New York City. He graduated from City College of New York and served in the American Air Force during World War II, when he began writing short stories. His first two books, *The Dark Arena* and *The Fortunate Pilgrim*, which drew on his background and ethnic heritage, received positive reviews; however, he was still struggling to support his wife and five children. That led to his writing of *The Godfather*, his most famous work, which was published in 1969 and dealt with the lives of mafia organization families. Soon made into a blockbuster movie that brought him fame and fortune, it did not change his modest and unassuming lifestyle. In 1968, Puzo bought the model house in a development on Long Island in Bay Shore, which he later remodeled, and he continued writing

books on similar themes that contained many references to Long Island, many of which became bestsellers. After Mario's wife, Erika, died in 1968, her nurse, Carol Gino, became his companion. Puzo died in his Long Island home in 1999.

Television Personalities

Savini

Laura Savini, who is familiar to Long Island television viewers of WLIW 21, grew up in Massapequa and graduated from Massapequa High School before launching a career as a public relations specialist. She has been vice-president of marketing and communications on WLIW and has raised millions of dollars on the air for its fundraising drives. She has received awards for exemplary service to the community, for serving on the advisory board of Telicare—the television station for the Diocese of Rockville Centre—and been designated the Italian American Women's "Rising Star." Savini also is a Massapequa High Hall of Fame honoree.

Mangano

Joy Mangano, raised in Huntington, is a single mother of three whose propensity for invention has been hugely successful. She has a degree in business administration from Pace University, and while a young woman, she developed a fluorescent flea collar to keep pets safe. She not only is credited with over one hundred inventions, including a self-wringing Miracle Mop and Huggable Hangers, but also is president of Ingenious Designs, which she sold to a television marketing company. She appears regularly on television's HSN (Home Shopping Network). One of the most creative people in Long Island business, in 1997, Mangano was named Long Island Entrepreneur of the Year.

Lisante

Monsignor James Lisante, after serving as a director of the Office of Family Ministry for the Diocese of Rockville Centre, serves as pastor of Our Lady of Lourdes Church in Massapequa Park. The author of four books, he has long been active in the popular media as host of several national television programs, including *Personally Speaking* and *Christopher Close-Up*. He is also a regular contributor to Fox News Channel and ABC's *Eyewitness News* and has also appeared on **PBS, MSNBC, CNN, CBS** and *Nightline* with Ted Koeppel. He writes columns appearing in over three newspapers.

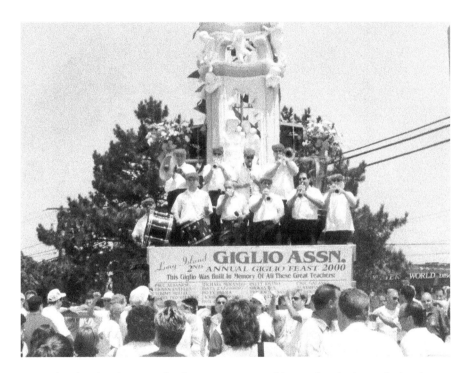

A ten-piece band and seventy-five-foot tower supported by one hundred men during the Giglio Feast celebration at Sunrise Mall in Massapequa, 2000.

Father Mangano

In addition to his role as pastor of Cure of Ars in Merrick, Father Charles Mangano also enjoys popularity because of his love of music. Growing up in New Hyde Park, he manifested an interest in music as a youngster of twelve, learning to play guitar and singing with family members who entered CYO competitions. Upon becoming a priest, he has integrated his music into a priestly ministry. He has teamed up with his sister Laurie to appear in concerts and television, as well as to make several albums of religious songs.

Father Charles Mangano, pastor of Cure of Ars in Merrick, together with his sister Laurie present a unique and fine music ministry. *Courtesy Laurie Mangano.*

Monsignor Gaeta

Now retired, Monsignor Francis Xavier Gaeta, who has served in many parishes throughout the Diocese of Rockville Centre, came to public attention during his tenure as pastor of Saint Brigid's Church in Westbury when *Newsday* focused on the remarkable dynamism he brought to parish life. It described Monsignor Gaeta as an unassuming but emotional personality with a genius for leadership that energized an extraordinary mix of races, languages and nationalities in the multiethnic congregation. Father Gaeta led the way to save Saint Brigid's parish school and nearly erased the parish debt.

Reverend Libasci

Reverend Peter A. Libasci, born in Queens, was ordained a priest of the Rockville Center Diocese in 1978 and served in several Long Island parishes. In 2007, he became an auxiliary bishop of Rockville Center, remaining in that post until he was named bishop of the Diocese of Manchester, New Hampshire.

Reverend Provenzano

In 2009, Reverend Lawrence C. Provenzano became the first of his nationality to be elected bishop of the Episcopalian Diocese of Long Island. Originally a Catholic from Brooklyn, he became an Episcopalian priest and served in various parishes in New England before coming to Long Island.

Sister Gallina

Sister Kathleen Gallina, who is of Italian-Sicilian heritage by virtue of her father, has been a Dominican sister for more than forty years. She holds teaching degrees from Molloy College, a master's degree in theology from Immaculate Conception in Huntington and a professional diploma in administration and supervision from Saint John's University. While remaining an active participant of her Dominican Religious Community,

Dominican Sister Kathleen Gallina, principal of Saint Rose of Lima School in Massapequa for over twenty years, shares an Irish (mother) and Italian (father) heritage. *Courtesy Sister Gallina.*

she also has established herself as a respected school administrator. Her career in education includes teaching for several years and being part of elementary school administration, serving as assistant principal in Saint Agnes, Rockville Centre, and principal in Long Beach Regional School in Long Beach. Her twenty years as principal of Saint Rose of Lima Parochial School in Massapequa have won widespread respect and admiration.

Father Pizzarelli

Father Francis Pizzarelli is one of five children who grew up in Massapequa. He became a Montfort Missionary Roman Catholic priest who studied at Saint John's University and other notable universities. One of the busiest

priests in the diocese, he often celebrates Mass at several churches and serves as hospital chaplain, in addition to teaching courses at Suffolk Community College and Saint Joseph's College. He is perhaps best known for founding Hope House in Port Jefferson in 1980, an organization that works with troubled youngsters overwhelmed by societal demands. When he began Hope House, he was thinking of temporary emergency shelter for needy young people caught up in drugs and other vices. However, it has become his life's work.

CINEMA AND SHOW BUSINESS

Long Island represents a rich vein of talent that has enriched the world of cinema and stage. Among them are many Italian Americans, a few of whom will be cited here.

Lupone

Few actresses can match Patti Lupone's theatrical legacy that is traced to her great aunt, world-renowned opera star Adelina Patti. Born and raised in Northport, Long Island, in a home that was filled with Italian relatives, language and music, she attended Northport High School and Julliard Preparatory dramatic school simultaneously in preparation for a stage career. Patti received a Tony Award for Best Leading Actress in a Musical for her leading role in *Evita* and continued to play many award-winning roles in plays such as *Sweeney Todd* and *Driving Miss Daisy*. She is married and has one child.

Davi

Born in Queens, Robert John Davi moved to Long Island while a youngster. Robert was influenced by the Italian culture, language and classical music that permeated the Davi household. He attended Catholic schools, including Seton Hall High School and, because of its prestigious theater department, went to Hofstra University. He began making films as a character actor in 1977 and hit a peak as the villain in *License to Kill*, a James Bond film. He

also played in television series and did screenwriting and directing that won awards. In recent years, Davi has performed as a singer, reprising Frank Sinatra ballads.

Lucci

Born in Westchester County, the Lucci family moved to Long Island, where Susan Lucci attended Garden City High School. She graduated from Marymount College with a degree in drama and became an actress, enjoying huge success in television soap operas, especially the long-running *All My Children*. She is married, has two children and also is a grandmother. For the last few years, she has been playing a starring role in *Boardwalk Empire*, a made-for-television series.

Buscemi

Born in Brooklyn of an Irish-descended mother and an Italian American father and raised a Catholic, Steve Buscemi moved to Valley Stream, Long Island, as a youngster. He attended Valley Stream Central High School, Nassau Community College and the Lee Strassberg Institute for acting while working as a member of the New York City Fire Department. Steve's lasting ties to the fire department were demonstrated in the wake of the bombing of the World Trade Center on September 11, 2001, when he promptly returned to his old firehouse and spent hours digging through the rubble seeking missing firefighters. He started making films as a tough-guy character actor and came to the attention of a wider audience with his performance in *Reservoir Dogs* in 1992.

Danza

His father is of Italian ancestry, and his Sicilian-born mother gave Tony Danza the birth name Antonio Salvatore Iadanza. His family moved to Malverne, Long Island, where he attended high school. His athleticism won him a wrestling scholarship to the University of Dubuque and inclined him to a professional boxing career for a time. As an actor, he became popular first as Tony in the successful television comedy series *Taxi* and other shows

such as *Who's The Boss?* and *Tony Miceli*. Never forgetting his Long Island roots, in March 2013, he returned to Malverne to serve as a bartender in a fundraising effort to help finance a school trip.

Alda

Alan Alda comes by his Italian ancestry via his father, Robert (Alphonso Giuseppe Giovanni Roberto D'Abruzzo) Alda, who also was an actor. Alan became an actor who appeared in a number of movies; however, he became a crowd favorite actor on the television screens of the 1970s and 1980s for his starring role as Captain Benjamin "Hawkeye" Pierce in the hit series *M*A*S*H*. In addition to acting, Alan has always had a fascination for science, a passion which he turned into a respected activity by promoting the idea of teaching researchers how to convey complex subject matter in simple, comprehensible ways. For several years, Alda, who has a home on Long Island, has served as host of *Scientific American Frontiers*, an award-winning science series on **PBS** that focuses on informing the public about new technologies and discoveries in science. Alda's ability to blend genuine curiosity and humor to the exploration of the latest trends in science, medicine, technology and the environment proves to be a unique method of making the subject interesting and informative. That Alda has been able to transform a hobby into a useful instrument is further evident in the 2013 decision of Stony Brook University to name a center after him: the Center for Communicating Sciences. His commitment to the center's work has resulted in raising millions of dollars for it to operate.

Marino

Born in 1968, in West Islip, Long Island, Ken Marino (Kenneth Joseph Marino), the son, grandson and nephew of clam diggers, graduated from New York University's Tisch School of the Arts with a bachelor's in fine arts. At various times, actor, comedian, director, producer, screenwriter and composer, he honed his craft in school productions, off-Broadway shows and writing scripts for MTV. He had feature roles in such television series as *Men Behaving Badly* and *First Years* and a recurring role in *Dawson's Creek*. He then began to appear in films such as *Gattaca* (1997), *Wet Hot American Summer* (2001) and *Tortilla Soup* (2001).

However, it was with his movie *Diggers* (2007) that Marino demonstrated theatrical abilities that extended beyond acting into the realm of writing screen scripts and movie producing. A coming of age film that reflects the difficulty of earning a livelihood—an experience his own family had when it was victimized by big business that bought up rights to the most productive clam areas—*Diggers* is the story of Long Island clam diggers striving against the odds as they troll the bottom waters off the South Shore in search of a depleted and shrinking resource. Marino is one the principal actors in the movie, which led one reviewer to comment about the film's integrity: "If the four friends and the women in their lives make up a stereotypical cross-section of thirty somethings, the seamless ensemble acting and the way the screenplay captures the deeper realities bared in offhanded conversation make the characters seem alive and spontaneous." Later, Marino has cowritten, coproduced and appeared in *The Ten* (2007) and *Role Models* (2008). He is married and has one child.

THEATER AND PERFORMING ARTS

An affinity between theater, the performing arts and Italian Americans was part of Long Island's experience virtually from the beginning of immigrants' appearance in several communities. The attraction initially was reflected in colorful performances of the ethnic theater that emerged in Italian enclaves such as Port Washington, where as early as 1912, broadsides advertised the forthcoming local appearance of an Italian comedy show featuring a theatrical group from Brooklyn; additionally, Italian-speaking performers frequently entertained residents of other local Italian enclaves. The ethnic theater flourished for a time in Westbury, where immigrant John Monteforte wrote his own play in the Neapolitan dialect, one that resonated with the local Italian population. Like the Italian ethnic theater that characterized big city Little Italies, most of the offerings revolved around the pathos and nostalgia of the immigrant saga or comedy.

Calderone

It would be merely a matter of time before this background prompted some to become influential figures in Long Island's theater world beyond

The plaque recognizing Salvatore Calderone as theater pioneer in Nassau County.

the ethnic locus. Undoubtedly, the first of these was Salvatore Calderone, who can properly be called the pioneer theater builder of Nassau County and who, with his son Dr. Frank Calderone, also a world-famous physician, established the island's most extensive theater chain that brought quality entertainment in the form of stage shows and films. Born in the historic town of Cefalu, Sicily, Salvatore opened his first movie house, the Hempstead Theatre, in 1922, an enterprise that met with such instant success that he was able to use the profits to start a circuit of theaters that expanded beyond Hempstead to Westbury, Lynbrook, Valley Stream, Mineola and Glen Cove. When Salvatore died in 1929, his son Frank took over the operation of the movie chain. Frank's other career was in medicine. He was a graduate of NYU's medical school, and his third marriage was to Dr. Mary Steichen, daughter of the famous photographer Edward Steichen. He and Mary became prominent promoters of public health in New York City. Notwithstanding that activity, he continued to operate the theater chain, building his last movie house, the Calderone Theater, in 1949 in Hempstead. It was originally designed as a movie palace to compare with New York's famous Radio City Music Hall. While falling short on these ambitious plans, the theater nevertheless was a gem of a building whose interior walls were a series of architectural planes brightly colored and indirectly lighted. Seats provided maximum legroom, while its lounges, powder room and restrooms featured modern furniture with specially woven upholstery fabric. Described

as "America's largest postwar theater," it was designed to seat over 3,500 and clearly was the most popular theater in Nassau County for decades. As the neighborhood declined and tastes changed, the theater went through a series of uses and operators, ultimately getting split up into a seven-screen multiplex. Like its major movie theater counterparts elsewhere during that era, the movie house was built lavishly, providing moviegoers a feast for their eyes with its ostentatious marquees and lavishly opulent interiors. These venues brought entertainment in the form of stage shows and films that Long Islanders enjoyed for decades. Eventually, the Calderone chain was sold to the Skouras movie house circuit.

Lombardo

Born of Italian immigrant parents in Canada, Guy (Gaetano) Lombardo had become a national musical celebrity whose band became a fixture playing "Auld Lang Syne" annually at New Year's Eve celebrations. Lombardo's role in Long Island's theatrical history emanated from his settlement in Freeport in the 1950s. He achieved additional fame for his record-breaking performances in hydroplane speedboat racing and for his productions in the Jones Beach Theater, which was rebuilt in 1952 specifically for summer shows that allowed for Lombardo to come in on his speedboat to introduce the performance and later end the night leading his band in a few tunes. Lombardo became promoter and musical director of this venue, which inaugurated its productions with *Around the World in 80 Days* and completed its water show series in 1977 with the staging of *Finian's Rainbow*.

Izzo

In the 1980s, Louis Izzo became an unlikely theater promoter in Long Island. A Bronx supermarket owner, real estate dabbler and theater devotee, he inherited his theatrical affinity from his grandfather, who played vaudeville in New York City streets in the 1920s. In 1980, Izzo rented the top floor of his supermarket on Arthur Avenue to the Belmont Italian American Playhouse to encourage theatrical companies to perform classical Italian plays. That background and his visits to Chelsea Center in Nassau County whetted his appetite to promote theater on Long Island—a desire that was fulfilled in

the Maguire Theater on the campus of the State University of New York in Old Westbury that began to present summer theater offerings. Summoning artistic director Dante Alberti from the Belmont Italian American Playhouse, the first offering of this new Long Island enterprise in 1988 was an Italian classic, *Filumena*.

Castaldi

Diane and Robert Castaldi, owners of the renovated Suffolk Theater, a possible harbinger for revival of downtown Riverhead, Long Island. *Courtesy Bob Spiotto*.

Possessing a real estate background, Robert Castaldi, president of Pike Realty, and his wife, Diane, in 2005 purchased the long-vacant, formerly regal Suffolk Theater in Riverhead for $707. From the outset, Bob's plan was to renovate the inimitable art deco–style movie house, which originally opened its doors in 1933 and operated as a movie theater until it closed its doors in 1987, into a performing arts center and single-screen movie theater. There followed frustrating years of delays and legal wrangling, but Castaldi persisted and virtually exclusively funded Suffolk Theater's rehabilitation in hopes not only of returning it to its former grandeur but also of using it as the central fulcrum to downtown Riverhead's rehabilitation.

Spiotto

In 2012, Castaldi hired Bob Spiotto of Holbrook as Suffolk Theater's executive director, who would be responsible for producing the theater's shows and entertainment vehicles. Spiotto was an outstanding choice with decades of experience as executive producer of Hofstra University's entertainment division, where he produced and directed shows for the university's arts center. Spiotto is also an accomplished actor and performer, who, among other things, conducted programs on Italian Americans such as songwriter Harry Warren (Salvatore Guaragna) and balladeer Perry Como.

On March 2, 2013, the Suffolk Theater reopened with a spectacular gala affair. The theater's bright lights washed out over dark Main Street, which was lined with Model A Fords in an effort to re-create the theater's original grand opening in 1933. Hundreds of men dressed in tuxedos escorted women in flowing gowns onto the red carpet that led into the magnificent multipurpose venue. An orchestra played music and couples in 1930s attire danced the Charleston, fox trot and Peabody. It is the hope of the Castaldis and Spiotto that the renovated theater will spark a resurgence of downtown Riverhead.

Amoroso

A strong sense of his ethnic roots marks the work filmmaker and documentarian Marino Amoroso, who has his work studio in Bohemia, Suffolk County. Born in Brooklyn, his family moved to Long Island while he was a youngster. Amoroso studied film at Emerson College in Boston and proceeded to make dozens of documentaries on film legends such as John Wayne and Italian American celebrities such as Rocky Marciano, Yogi Berra and Frank Sinatra. His work has been shown on television. Amoroso's love of Italian culture informed his 1999 *Our Contributions: Italians in America* documentary and his novel *Across the Street*.

ITALIAN AMERICAN ORGANIZATIONS

Unico

Activities and events that revolve around Italian ethnicity are at the core of several large and small organizations. Unico and Order of the Sons of Italy in America are among the large organizations that have a Long Island presence. Unico, the largest Italian American service organization, has as its goal promoting and enhancing the image of Italian Americans, in particular, urging its members to be of service to the community. It seeks also to promote Italian heritage, a goal demonstrated by the Smithtown-Islip chapter that cosponsors Italian Heritage Day at Nassau Community College.

Order Sons of Italy in America (OSIA)

The oldest and largest fraternal Italian American organization is very active on Long Island, where it consists of two districts that encompass thirty-one lodges, from the oldest, Loggia Glen Cove, to the newest, Vigiano Brothers Lodge in Port Jefferson. The Vigiano Lodge is named after John Vigiano, a New York City fireman, and his brother Joseph Vigiano, a policeman—both of whom were killed in the September 11, 2001 World Trade Center Bombing. Individual lodges conduct numerous activities that are designed to raise money for charitable programs such as scholarships, support of Italian-language programs and funding medical research to find a cure for Cooley's anemia. Since 1979, OSIA has sponsored the Commission for Social Justice (CSJ), the antidefamation arm of the New York Grand Lodge. The CSJ is the foremost Italian American group designed specifically to engage in the work of combating the defamation of Americans of Italian heritage and other ethnic groups. The two primary goals of the CSJ are to fight bias, bigotry and discrimination aimed at Italian Americans and to promote the positive image role model of Americans of Italian descent.

Long Island OSIA lodges sponsor Columbus Day parades locally, as in Port Washington and the Long Island Columbus Day Parade held in Huntington. Long Island's OSIA members are prominent in other ways. Presidents of the New York State Grand Lodge have come from Long Island in recent years, including Joseph Sciame, Joseph Cangemi, Carlo Matteucci, Salvatore Lanzilotta and Thomas Lupo, for instance, and even national presidents

Enrico Annichiarico, chairman of the Commission for Social Justice for OSIA with his wife, Camille, busy promoting the good name of Italian Americans, 2012.

Camille Annichiarico and Lou Gallo man an OSIA booth at the Hofstra University Italian Festival, 2012.

Grand Lodge of New York's building in Bellmore.

Joseph DiTrapani, honored at a solidarity breakfast cosponsored by the Commission for Social Justice and B'nai Brith, is national president of the Order Sons of Italy in America.

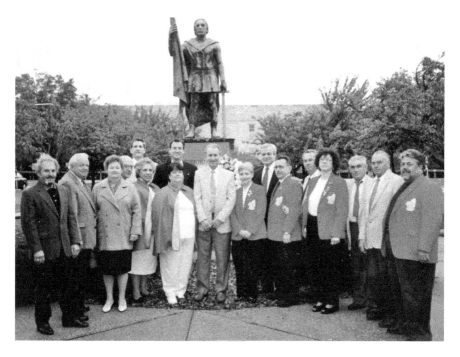

OSIA members attend a wreath laying at the Columbus Statue in Mineola, circa 2000.

Joseph Sciame and Joseph J. Di Trapani. Likewise, many state chairpersons of the CSJ also are Long Islanders such as Enrico Annichiarico, current CSJ state chairman, and Santina Haemmerle, national CSJ president. The nonprofit organization has contributed hundreds of thousands of dollars to many worthwhile charitable activities, including medical research and educational causes.

Colleges

Programs designed to educate and promote the contributions of Italian Americans to society are to be found in Long Island colleges. An Italian American studies component led by Dr. Stanislao Pugliese exists at Hofstra University, and the college also sponsors an annual Italian Festival Day. For over twenty-five years, Dr. Salvatore J. LaGumina has served as chairman of the Center for Italian American Studies at Nassau Community College that sponsors an annual Italian Heritage Day, while at Stony Brook

Italian American Women's Center, Inc., promoting its organization at the Hofstra University Italian Festival, 2012.

Part of the crowd enjoying the Hofstra University Italian Festival, 2012.

American Italian Historical Association, Long Island chapter, annual luncheon at Pompeii Restaurant, West Hempstead, 2001.

The Italian Genealogical Group successfully encourages its members to explore their family histories.

University, Dr. Mario Mignone is the director of the Center for Italian Studies that holds conferences exploring Italian language and culture. Stony Brook University has also established an endowed professorship in honor of Senator Alphonse D'Amato.

Italian Genealogical Group

The mission of Long Island's Genealogical Group is to further Italian family history and genealogy. It seeks to accomplish this by having regularly scheduled meetings of those interested in the subject to become better acquainted with local and regional databases that provide useful information to develop family and regional histories.

CONCLUSION

Notwithstanding extant differences of opinion, recent studies suggest that ethnicity remains a powerful and contentious force in American society. For at least the last four decades, Italian Americans—around 25 percent of the total population—have remained Long Island's largest single nationality group and have accordingly manifested various dimensions of adherence to a national background. Perhaps somewhat attenuated, ethnicity persists among Italian Americans and is evident in ongoing Italian American organizational life. Natural disasters in Italy, while evoking a general sympathy among Americans, are of particular concern to Long Island Italian Americans, who responded generously to the need for aid to the survivors of the 1980 Irpinia earthquake that led to the deaths of thousands of Italians and left large numbers homeless. Italian American college professors joined with local Sons of Italy lodges to raise funds while a similar outpouring of deep concern was manifest by Long Island Italian Americans following the 2009 earthquake in L'Aquila in the Abruzzo region. For Italian immigrants of the 1950s and 1960s, a soccer match between the Italian and the United States team can be a source of mixed loyalties, as in 2006 when dozens gathered at Nico's Caffe Calabria in Glen Cove to cheer the Italian team against the Americans. Meanwhile, some 150 people waving Italian flags dressed in team colors emotionally celebrated the event at Amici Family Style Restaurant in Massapequa. The informal relationships between Long Island and Italian towns are another indication of ethnicity's strength. One example occurred in the 1990s, when

A ceremony between the mayor of Durazzano, Italy, and Westbury Village mayor Ernest Strada (third from left) affirming the sister relationship between the two villages, 2008. *Courtesy Ernest Strada.*

representatives from Durazzano's municipal government in Italy came to Westbury, where the village mayor and other representatives of Italian organizations hosted a reception in the village hall for the visitors. In 2007, Westbury mayor Ernest Strada visited Durazzano, where the town's officials publicly acknowledged the bonds existing between the two communities. In 1986, Glen Cove's mayor, Vincent Suozzi, whose late parents came from an area near Sturno, Italy, sent souvenirs of Glen Cove to the mayor of Sturno as the Glen Cove city council voted to adopt Sturno as a sister city. Another instance occurred in 2012, when delegation from Sassano, Italy, exchanged gifts and words of thanks with Glen Cove officials as part of its visit to Long Island. The group also attended the Glen Cove Fire Department's recent 175th anniversary celebration.

The transition from urban to suburban settings occurred with remarkable rapidity, readily verifiable in census figures that showed huge increases in Long Island's population in the last half of the twentieth century. And people of Italian ancestry were ubiquitous—they seemed everywhere to head the lists of newcomers. In truth, they formed the largest nationality cohort of

newcomers. Long Island Italian Americans have made a remarkable journey from the periphery of society to a central and indispensable place in the island's economic, social, religious and cultural life. Recent studies show that they enjoy a median family income and a per capita income greater than their counterparts and average Americans throughout the country. Their rate of poverty is much lower than the national average, and their educational attainment is on a par with average Americans. In a word, they have come a long way toward realizing their potential. Nor was their presence evident only numerically; they were omnipresent in virtually all walks of life. In November 1971, the *New York Times* commissioned writer and bricklayer Pietro Di Donato who had moved from Brooklyn to East Setauket to write about the phenomenon. In his own inimitable style, the celebrated author offered a colorful description of Long Island Italians and one that may serve as a useful retrospective of their attraction to and impact on the region:

> *Italians came to "Longa-Eye" estates as cooks and gardeners, and as master stone carvers, masons and marble setters for the castles of the tycoons. They came on outings to la campagna by horse and wagon, the L.I.R.R. and Model T peddlers' trucks to hunt the magic mushroom, pick dandelion, poke weed and wild grape, and to dig clams and mussels and conch and fish and spear the darling eel.*

The broken English mimicry of the immigrant generation evoked by Donato only begins to underscore the attraction Long Island represented to Italian Americans. And thus it was not only the immigrant generation but also their children, grandchildren and great-grandchildren that found the American dream on this remarkable island.

INDEX

ABOUT THE AUTHOR

S alvatore J. LaGumina is an emeritus professor of history at Nassau Community College, where he serves as director of the Center for Italian American Studies. He was born and raised in Brooklyn, New York, received his bachelor's degree from Duquesne University and his master's degree and doctorate from St. John's University. He has lectured extensively in major universities in the United States and abroad. A past president of the American Italian Historical Association (AIHA), he also was the founding president of the Long Island Chapter and is the author and editor of dozens of scholarly articles and nineteen books, including *The Italian American Experience: An Encyclopedia*; *Wop: A Documentary History of Anti Italian Discrimination*; *From Steerage to Suburb: Long Island Italians*; *Long Island Italians*; *Hollywood's Italians: From Periphery to Prominenti*; *The Humble and the Heroic: Wartime Italian Americans*; and *The Great Earthquake: America Comes to Messina's Rescue*. The last two books were recipients of the Pietrio Di Donato and John Fante Literary Awards. He is married, the father of four children and lives on Long Island.

Visit us at
www.historypress.net
..
This title is also available as an e-book

CPSIA information can be obtained
at www.ICGtesting.com
Printed in the USA
BVHW040737180720
584022BV00007B/54